CALIFORNIA'S
LAMSON
MURDER MYSTERY

CALIFORNIA'S
LAMSON
MURDER MYSTERY

The Depression-Era Case that Divided Santa Clara County

TOM ZANIELLO

THE
History
PRESS

Published by The History Press
Charleston, SC
www.historypress.net

*Front cover, top left: author's collection; top center: courtesy Special Collections, Stanford
University; top right: courtesy Library of Congress; bottom: courtesy History San Jose.
Back cover: author's collection; top insert: courtesy History San Jose; bottom insert: courtesy
Special Collections, Stanford University.*

First published 2016

Manufactured in the United States

ISBN 978.1.46713.653.2

Library of Congress Control Number: 2016941431

Notice: The information in this book is true and complete to the best of our
knowledge. It is offered without guarantee on the part of the author or The
History Press. The author and The History Press disclaim all liability in
connection with the use of this book.

The more one investigates criminal trials of the past fifty or one hundred years in America and in England, the harder it is to find one well-established instance of the execution of the death penalty on an innocent person.
—*Edmund Pearson,* Studies in Murder *(1937)*

Sometimes in cases where the investigators rely on circumstantial evidence the officers jump at conclusions with too much haste. They form an opinion as to the identity of the culprit, and, because they have that opinion and because they are sincere in their belief, they collect only the factual evidence which tends to support their theory. Other facts are discarded because they are "not pertinent."
—*Erle Stanley Gardner,* The Court of Last Resort *(1957)*

CONTENTS

ACKNOWLEDGEMENTS

Yvor Winters and Janet Lewis, David Lamson's friends and advocates, inspired this book. Lewis encouraged my interest in Lamson in an interview arranged by Brigitte Carnochan and introduced me to Lamson's daughter. I learned of Winters's tenacity and intellectual power as a graduate student in his contemporary poetry course at Stanford University. Melissa K. Winters, their granddaughter, kindly provided me with photographs of them for this book.

Robert L. Barth, poet, publisher and friend, was the editor of Winters's correspondence and selected poems and Lewis's poetry and has supported this project in many ways.

A big thank-you for Emily Taylor's design of the Lamson home.

Ken Fields and Brigitte Carnochan were generous with excellent advice as I pursued this story.

The University Archives and the Special Collections of the Stanford University Library have provided extraordinary service for my research and photograph needs.

Catherine Mills of History San Jose has been very helpful in securing important illustrations for this book.

At the Santa Clara county clerk's office in San Jose, Madeleine Sheinman and Monica Masari facilitated my research into the legal files of the case.

Reporter Jeff Brazil and librarian Pam Allen of the now-defunct *Peninsula Times-Tribune* (formerly the *Palo Alto Times*) were very helpful for my research.

The late Benjamin D. Paul, Stanford University professor, lived at the former home of the Lamsons at 622 Salvatierra Street and was a gracious host for my visits there.

For careful readings of a very early draft that has resulted in numerous improvements, I would like to thank Robert L. Barth and Beverly Storm.

The staff of the Cincinnati Public and the Northern Kentucky University libraries, especially the latter's Interlibrary Loan Office, formerly led by Sharon Taylor, have been very supportive of my research.

I am grateful to Northern Kentucky University for a sabbatical and research grant that enabled me to finish a draft of this book.

1.

THE DARK SIDE OF THE
VALLEY OF HEART'S DELIGHT

S ilicon Valley is the latest nickname for the Santa Clara Valley of the San Francisco Peninsula, but in the early twentieth century, it was known as the Valley of Heart's Delight, an Eden of the World, even Paradise. San Jose, its principal city and county seat, was the Garden City.

A legal lynching and a vigilante lynching disturbed the peace in 1933, although this valley of endless orchards of apricots and plums had already been plagued by corrupt goverment, gambling, labor unrest and vigilantes.

The legal lynching, orchestrated by a county political boss, the Santa Clara County sheriff and the district attorney, led to the wrongful conviction of David Lamson for the murder of his wife, Allene Warden Thorpe. The couple had been married on June 18, 1928, on the Stanford campus. Five years later, Allene Lamson was found dead in the couple's bathroom; after a scandalous murder trial, her husband was sent to San Quentin for execution.

Soon after Lamson arrived at San Quentin, two foolish kidnappers killed Brooke Hart, the well-known son of a San Jose businessman, and they were lynched in San Jose by a mob led in part by the victim's friends and classmates from Santa Clara University.

The lynching was the beginning of the end of the corrupt leadership in Santa Clara County, but fruit cultivation eventually gave way to microchip production, as the tech companies of Silicon Valley replaced the orchards.

The Santa Clara Valley stretches west and south of San Francisco Bay, lying between the Santa Cruz Mountains on the Pacific coast and—ten to

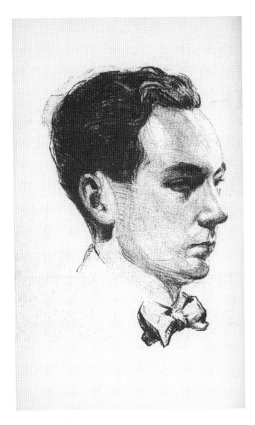

Drawing of David Lamson by an unknown artist, reproduced from *The Case of David Lamson: A Summary*, published in 1934 by the Lamson Defense Committee. *Author's collection.*

fifteen miles away as the dirigible flies—the foothills of the Mount Diablo Range to the east. Its neighbor is San Mateo County, lying to the north and west and continuing as the west shore of the bay to the southern border of San Francisco. The line dividing the two counties is the northern boundary of Stanford and Palo Alto, the small city historically tied to the university.

For years, the only tangible reminder of the Valley of Heart's Delight was a brand of fruit juice: Heart's Delight Apricot Nectar was a product of the Nestle Food Corporation, even when the valley did not supply the apricots. Sunsweet, the first company to can prune juice for commercial sale, also originated in the valley.

Until World War II, the Santa Clara Valley was one of the most fertile growing areas in America, supplying fresh, canned and dried fruits under a seemingly endless sun from April to October and from a seasonal but plentiful supply of water. Janet Lewis, a novelist and poet who lived in Los Altos "across the road" from "20 acres of apricots and prunes," described this valley, her lifelong home, in *Against a Darkening Sky* (1943):

> *In March, roses were in bloom, and the orchards of the Santa Clara Valley had begun the slow procession of fragrance and blossom which was to last another full month, first the almonds, then Imperial prunes, then apricots and French prunes, and peaches, cherries, apples, pears—the almond trees breaking into green as the apricots turned snowy, apricots in green leaf as the prunes came into blossom, apples and quinces mixing leaf and blossom on the single twig.*

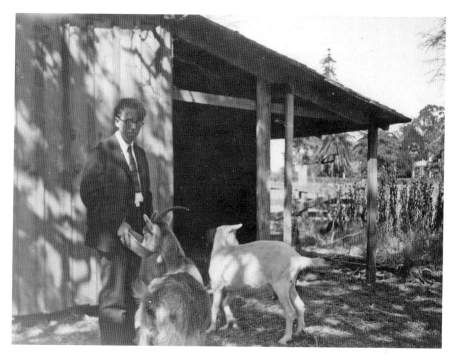

Yvor Winters, Stanford University professor and leader of the Lamson Defense Committee, with goats at home in Los Altos, 1930s. *Courtesy Melissa K. Winters.*

Lewis and her husband, Yvor Winters, Stanford University professor and poet, thrived here: they cultivated a garden and an orchard with a remarkable variety of fruits, raised goats and showed Airedales competitively. A mountain lion that wandered the streets of San Jose in 1933 no doubt reminded them of the years they spent in New Mexico recuperating from tuberculosis.

Chicano novelist Jose Antonio Villarreal similarly remembered his Mexican American neighborhood nearby in Santa Clara in *Pocho* (1950), set in the early 1930s:

> *It was spring in Santa Clara. The empty lots were green with new grass, and at the edge of town, where the orchards began their indiscernible rise to the end of the valley floor and halfway up the foothills of the Diablo Range, the ground was blanketed with cherry blossoms, which, nudged from their perch by a clean, soft breeze, floated down like gentle snow.*

Pocho's family settles in Santa Clara, but many Mexican migrants rotated home at the end of the harvest.

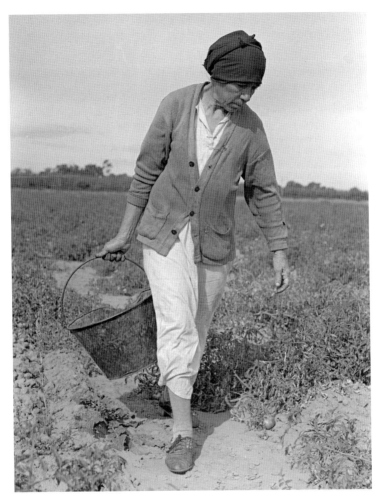

Mexican grandmother who migrates with large family every year…harvesting tomatoes, Santa Clara Valley, California. Photograph by Dorothea Lange, taken in 1937 for the Farm Security Administration. *Courtesy Library of Congress.*

The great staple crops were apricots, plums, peaches, cherries, apples and pears, the valley ranking first in county acreage for California in apricots and prunes in 1930. Prunes dominated in volume, while apricot trees covered more than 10 percent of the orchards. Prunes were shipped only dried, while apricots were distributed both dried and canned. The successful processing of dried fruit required one acre for a drying yard for every twenty acres of trees. Seen from a hilltop or a dirigible, the valley had the look of a crazy quilt.

Over the rich orchards of the Santa Clara Valley from Hamilton, CA. U.S.A. Left image of sterographic side taken at Mount Hamilton in the Diablo Range by the International Stereographic Company, circa 1906. *Courtesy Library of Congress.*

Janet Lewis celebrated the remarkable growing season of the valley in her poem "No-Winter Country," contrasting a friend's news about the spring thaw in a wintry region to the Santa Clara Valley, where any such drama seemed distant:

> *I feel becalmed in an eddy of time,*
> *Or shut by happiness, a great hill,*
> *Into a valley of calm, and still,*
> *These letters come from another clime.*

The great Southern Pacific Railroad, leasing the right-of-way from the Central Pacific Railroad of Stanford University's founder, Leland Stanford, was the key shipping route through the central spine of the valley. But the 1920s also saw the explosion of automobile and truck traffic up and down the peninsula, so much so that by 1932, truck deliveries directly from farm to city center had replaced much of the former rail freightage. The main traffic artery of the peninsula was U.S. 101, the highway that followed the right-of-way of California's oldest road, the Spanish El Camino Real. "The kings' highway" had been the lifeline of the old Spanish missions, farms and forts.

By 1933, the new Bayshore Highway (then U.S. 101-Alt.), hugging the San Francisco Bay on the east side of the valley, began the process that destroyed the Valley of Heart's Delight as an agricultural region, despite the road's importance for trucking produce. When the Bayshore Highway was in turn replaced by a limited-access Bayshore Freeway, Silicon Valley eventually came into being, creating a military-industrial complex stretching from San Francisco to San Jose.

Jan Broek, a Dutch geographer visiting the valley in the early 1930s, called the urban sprawl along the Bayshore Highway a "road slum." Broek's mentor, Benton MacKaye, had already predicted in 1928 that Boston's Route 128 expansion would create a circumferential belt of industrial and suburban development, eventually a technological twin of Silicon Valley.

Broek realized that between Palo Alto and Santa Clara "a bordering frontage of drab wayside architecture embellished with blatant signs" engulfed an incessant "metropolitan flow away from the cities." On this twenty-mile strip, goldfish hatcheries, dog kennels and plant nurseries framed the residences, orchards and vegetable and berry farms. Numerous "service hamlets"—clusters of gas stations, grocery stores and restaurants—also proliferated.

But there was a dark side to all these glorious orchards. Even the thousands of acres of prime agricultural valley could not, of course, avoid the Great Depression nor mask problems of racial prejudice, class conflict and crime. Chinese immigrants called California the Golden Mountain; indeed, the valley seemed to promise a rewarding life for all, but its unincorporated land attracted gambling and other corruption.

Thus the Santa Clara Valley was home not only to orchardists, an academic middle class and some very rich estate owners but also to immigrant workers, a pro-union white working class and gamblers' marks.

In the mid-1920s, only one school, Thomas Foon Chew's cannery school in Alviso, fourteen miles south of Stanford, permitted Chinese and white

Above: The Bayside Cannery and Chinese Dormitory Building in Alviso, Santa Clara County, 1930s–1950s. Historic American Buildings Survey. *Courtesy Library of Congress.*

Right: *Japanese try to sell their belongings*. Photograph by Russell Lee, 1942, for the Farm Security Administration. Office of War Information Collection. *Courtesy Library of Congress.*

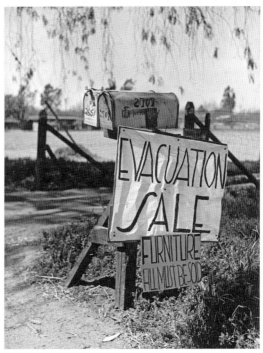

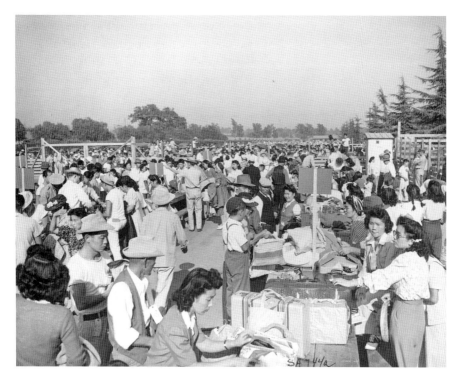

Transfer of the [Japanese American] *evacuees from the Assembly Centers to the War Relocation Centers was conducted by the Army.* Photograph by U.S. Army Signal Corps, 1942. *Courtesy Library of Congress.*

American children to attend classes side by side. Four thousand Japanese and Japanese Americans lived and worked on local farms in the 1930s, but they were relocated in 1942 to desert camps, via a repurposed Tanforan Racetrack, when the anti-Japanese evacuation orders were signed. And while many neighbors, like Lewis and Winters, respected their Japanese neighbors' homes until they returned, others squatted on their properties.

Both John Steinbeck's well-known *Grapes of Wrath* and Carey McWilliams's now virtually ignored *Factories in the Fields* appeared in 1939, at the end of a decade of turbulent farm workers' strife. Steinbeck's book dominated much of the cultural history of the region, in part, as McWilliams himself has acknowledged, because the Dust Bowl migration of the Oakies and Arkies seemed biblical in scope as they fled to the promised land. And while McWilliams's concern was wider, encompassing workers both white and Mexican, by 1934, for the first time ever, more than half of California's farm laborers were native-born and white.

Regardless of color or origin, the migrants faced many difficulties. Picking peas, for example, only paid a quarter for every thirty pounds, while in some areas of California one faucet was "the only source of water for 150–200 families camped in the brush," according to Dorothea Lange, the legendary photographer of migrant life who worked for the New Deal's Farm Security Administration, which tried valiantly to offer some relief in the form of better camps, similar to the one the Joads discover at the end of director John Ford's film of *The Grapes of Wrath* (1940). Her photographs also illustrated the more activist phase of Steinbeck's career when, in the mid-1930s, he reported on the terrible conditions of the "harvest gypsies" for a series of newspaper articles that became the best-selling pamphlet *Their Blood Is Strong*, published in 1938 with her photographs.

The drama of migrant, native "non-whites" and white farm labor in the Santa Clara Valley was, however, quite complicated. The cemetery city of Colma in adjacent San Mateo County had catered to this mix of peoples for generations. Formerly named Lawndale, the town had laid out separate

California pea pickers returning to camp after a day's work in the field. Near Santa Clara, California. Photograph by Dorothea Lange in 1937 for the Farm Security Administration. *Courtesy Library of Congress.*

Left: Migrant housing in Santa Clara Valley. Photograph by Dorothea Lange, taken in 1937 for the Farm Security Administration. *Courtesy Library of Congress.*

Below: Idle migrants. Foothills north of San Jose, California. Photograph by Dorothea Lange in 1939 for the Farm Security Administration. *Courtesy Library of Congress.*

nations of the dead—a Greek cemetery, a Serbian cemetery, an Italian cemetery, a Japanese cemetery and a Chinese cemetery. The rest of the world rested in nine other more generically named sites, such as Hills of Eternity, Home of Peace and Holy Cross, connected by only twenty-five local streets.

Janet Lewis described California in 1934 as "a land of turmoil." She told her friend, novelist Katherine Anne Porter, that "this is a wicked state,

Migratory labor camp in the Santa Clara Valley. Near San Jose, California. Photograph by Dorothea Lange in 1937 for the Farm Security Administration. *Courtesy Library of Congress.*

maybe a bit wickeder than most." Union organizing, strikes and "red scares" hit the Santa Clara Valley throughout the 1930s. Lewis called the San Francisco longshoremen's general strike "a just one, but there is going to be more trouble in the valley before the fruit-picking seasons are over." William Z. Foster of the Cannery and Agricultural Workers Industrial Union had led two thousand cannery workers out on strike the year before. When his union attracted Mexican braceros in the cherry orchards of Mountain View and Sunnyvale adjacent to Stanford, the San Jose police used members of the American Legion as deputies to stop his organizing. The Italian pear pickers also went on strike, protesting a cut in their wages from thirty to twenty cents an hour. Union successes were small: the pear pickers' rate was cut only five cents instead of ten. When Foster became head of the Communist Party of the United States, right-wingers everywhere felt empowered to do their worst.

Villarreal's *Pocho* dramatizes such struggles vividly, including a barn meeting where "a red flag with a hammer and sickle was the centerpiece." Villarreal's Mexican family, amazed to see "Negroes" in the Communist

Party's ranks, are inevitably drawn to strike until one of the orchard workers is killed with a rock for crossing the picket line.

The wave of labor unrest in the Depression boosted waves of vigilantism, from the dramatic San Francisco General Strike to smaller uprisings in the Santa Clara Valley. The *San Jose Mercury-Herald* reported on July 20, 1934, that "vigilantes" or "irate citizens, including many war veterans," attacked three communist "hot spots…seized a mass of literature, and severely beat nine assorted radicals." The vigilantes picked up four more suspects and turned the thirteen men, almost all of whom had Italian surnames, over to sheriffs in two counties south of the Salinas Valley for arrest on vagrancy charges. For these right-wingers, any union organizing was evidence of reds at work. Starving workers from other parts of the United States were of course naively rushing to California for jobs in short supply.

In neighboring San Mateo County, the law was also under siege. On its Pacific coast, Half Moon Bay provided a convenient roustabout port for smuggling booze for the whole Bay Area during Prohibition. In the 1920s, roadrunners, bootleggers, moonshiners and speakeasy operators were already commonplace; prostitutes and law officials on the take followed.

When the Tanforan Racetrack opened in San Bruno in 1930, sympathetic local judges ruled that dog racing—at first illegal in California—was legit because customers were not "betting" on the dogs but purchasing "options" to buy them. Off-track betting through bookies flourished as well. The mayor of Belmont and a local publisher opened a dog track of their own. At the county border with San Francisco, other Belmont track investors incorporated a new town, Bayshore City, where another dog track opened, supposedly run by Al Capone's men from Chicago. Bookie parlors followed with sympathetic local government support. Chinese gamblers also flocked to the new city when the heat was on in San Francisco's Chinatown. Their Oriental Gambling Emporium was soon the largest casino in San Mateo County.

A California referendum in 1932 had legalized parimutuel betting, creating numerous bookies, not only at the tracks but also in roadside houses that catered to illegal slot machines, as well as a full range of casino activities—cards, dice and lotteries. Five dog tracks were in operation by mid-decade. But Bayshore City lasted only seven years; by 1939, horse-racing enthusiasts had managed to outlaw dog racing, and the town disincorporated.

Clearly San Mateo was the local leader in illegal activities. What of Santa Clara County? Because of the original 1894 contract for the Palo Alto land held by Timothy Hopkins, the son of one of Leland Stanford's Big Four

friends, alcohol could not be sold in Palo Alto. Enterprising saloonkeepers, however, sold liquor to Stanford students in Mayfield, a nearby village. In 1934, 3.2 percent beer went on sale legally in Palo Alto for the first time, but Depression-era undergraduates with cars always had access to booze. Girls under seventeen joined rowdy undergraduates from the Stanford "Farm"; two Palo Alto teenagers testified in a juvenile court hearing in May 1935 about how easy it was to go for a beer at Stone's Cellar in Menlo Park, just a mile north of Stanford.

In the opposite direction, south on El Camino Real, and on the new Bayshore Highway, numerous gambling joints operated in East Palo Alto, an unincorporated pocket of land between Palo Alto and Mountain View that has always been challenged economically. A Santa Clara County grand jury reported to Judge R.R. Syer in March 1936 that gambling in general and pin games specifically—the Italian "bagatelle" in which a ball careens off obstacles and ends up in a scoring hole—were so widespread that "it raises a question as to the honesty and efficiency of city and county officials charged with the duty of suppressing unlawful gambling and seizing slot machines."

Pinball games for "the thrill of amassing a high score is pretty barren on a strictly amusement basis," an investigative reporter for the *Palo Alto Times* suggested, but what happened, of course, is that when a bartender felt safe, the customer playing these "games of skill" would receive a payoff if luck favored his toss. Slot- and pin-machine manufacturers argued that it was not their fault that the games were used illegally. They pointed with pride to Buckingham Palace, where they had placed a number of the machines, and added that the prince of Nepal had a slot machine for his amusement in his palace bathroom.

The unincorporated areas of Santa Clara County were under the jurisdiction of Sheriff George Lyle, who had succeeded William Emig in 1935. Lyle's approach to law enforcement, despite an anti-"criminal" campaign slogan, is best characterized as selective: there were no slot machines in cities like Palo Alto, he said, because he never needed "to make gambling raids in cities having their own police departments." He neglected to add that his gambling raids in areas without police departments were minimal.

After the grand jury's report was released in March 1936, an editorial in the *Palo Alto Times* commented on its earlier recommendation to "clean up" Santa Clara County by creating a county vice squad. Because "the illegal resorts…have notoriously enjoyed wide openness for some time," surely the sheriff by now should demonstrate some "genuine zeal" for eliminating

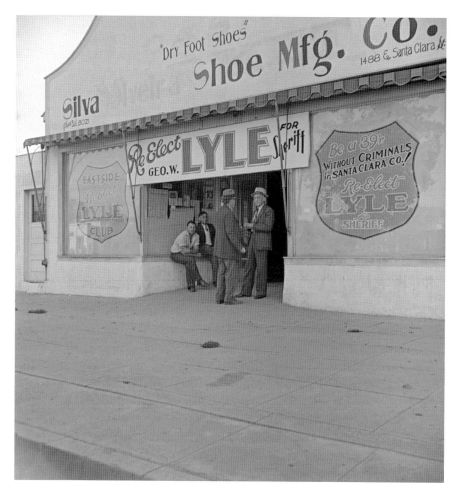

Campaign signs for George W. Lyle, running for sheriff of Santa Clara County against "criminals," photographed by Dorothea Lange in 1938 for the Farm Security Administration. *Courtesy Library of Congress.*

them. The editorial suggested concentrating on the incorporated areas—the sheriff's own idea, really—and dispatching some of the county constables who are "not overburdened with activity." Among such areas, perhaps surprisingly, was the campus of Stanford University, patrolled for the most part by its own traffic officers.

2.

STANFORD UNIVERSITY
DREAMS OF SILICON VALLEY

Stanford University exists because of a family tragedy: Leland Stanford Jr., the only child of Leland and Jane Lathrop Stanford, died in 1884 at age fifteen. His parents decided to found Leland Stanford Jr. University a year later as a memorial tribute to their (by all accounts) intelligent and curious son, a collector of art and archaeological bits and pieces now lovingly exhibited in the Stanford Museum. When the youth died in Italy after a short bout of typhoid fever, Leland Stanford told his wife, "The children of California shall be our children."

Leland Stanford could easily afford a considerable endowment. He was a former governor, one of the West Coast titans of business hailed (not always affectionately) as "The Big Four." The university was created just twenty-five years after Leland Stanford's personal rise to affluence and power.

As a successful small businessman in Sacramento, his support of Lincoln in 1860 led him within a year to become governor. An active Unionist, he secured California's substantial support for the Union cause in the Civil War, no doubt in return for the federal financing of a transcontinental railway line. Before 1860, proslavery forces wanted a southern route to the coast, while the North preferred something a little farther…north. With Secession in full swing, the northern route was further subsidized to keep California and the Nevada Territory, with access to gold and silver, Unionist.

While governor, Leland Stanford became the president of the Central Pacific Railroad Company, the pioneering financial scheme of the four Sacramento businessmen: Stanford, plus Collis P. Huntington, Mark

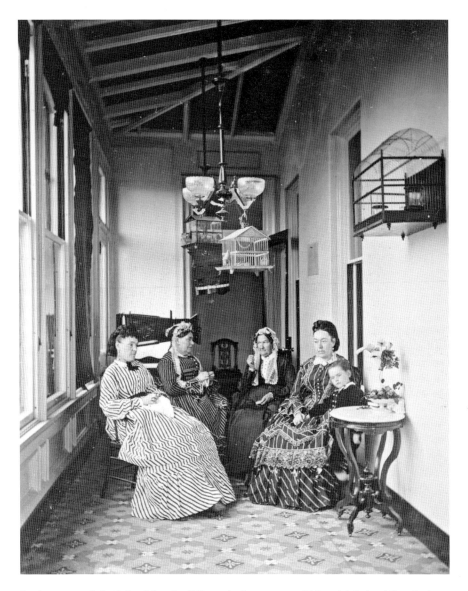

Sewing room of the Leland Stanford House in Sacramento. *Right to left*: Leland Stanford Jr., Jane Stanford, Governor Stanford's mother, Jane Stanford's mother and Jane Stanford's sister. Photograph by Eadweard Muybridge in 1872. Historic American Buildings Survey. *Courtesy Library of Congress.*

Hopkins and Charles Crocker. Their plan was to have their railroad meet the westward-driving Union Pacific as far east of California as possible and form the first transcontinental railroad. Closer to home, however, they would

Governor Leland Stanford and Mrs. Jane Stanford on an "invitation in an unidentified Sacramento Guide Book" in 1862, according to the Historic American Buildings Survey. *Courtesy Library of Congress.*

service the booming Nevada Territory with their dry goods. Stanford and the others in the Big Four were assured of their fortune when the two railroad crews, mostly Chinese and Irish immigrant workers, met at Promontory, Utah, on May 10, 1869.

Their financial risks, however, were not great. Federal, state, county and even city governments all generously financed the project and gave the company substantial land grants on the right-of-way. Stanford was simultaneously governor of California, president of the Central Pacific Railroad and a partner of the owner of the construction company hired by his own railroad to actually build the thing.

Stanford's two major acquisitions of the 1870s were a mansion on Nob Hill in San Francisco and the Palo Alto Stock Farm for breeding trotters. The latter provided land for Stanford University, still nicknamed "The Farm," because the Stanfords' founding grant included all 8,180 acres of the original farm. One of its horse barns is still used by the equestrian team, but its original claim to fame was as the site of Eadweard Muybridge's stop-motion photographs in 1878 of a horse running to determine if all four feet were ever off the ground at one moment. Besides documenting this fact, Muybridge went on to invent the first motion-picture "projector," the zoopraxiscope, perhaps Stanford's first technical breakthrough.

By 1885, Leland Stanford was both a U.S. senator and the founder of a new university. The Stanfords hired Frederick Law Olmsted, the internationally renowned landscape architect of Central Park, to develop a general plan for the university. The central core was a double (inner and outer) quadrangle of low buildings connected by arcades; this arrangement remains to this day, minus a church tower and a memorial arch, both felled by the great 1906 earthquake.

The first students arrived on campus in 1891, but Leland Stanford survived his university's inaugural class by only two years. Jane Stanford had to take charge, but rivalries with old financial allies threatened the university. Leland Stanford's estate was tied up in probate. The federal government attempted to seize the estate in partial payment of a $57 million debt it claimed on the Central Pacific Railroad.

The new university was potentially bankrupt before its third year had begun. Collis P. Huntington, whose partnership with Stanford had already turned unpleasant before the latter's death, suggested that Jane Stanford close the university and "stop the circus!" Huntington tried to isolate her by using his own wealth and power to drive his former best friend's estate into the government's pocket to settle the railroad debt so that, when he died, his

own estate would be clear. He would not be able to take it with him, but he didn't want it to go to Washington, either.

His plan was based on simple arithmetic: both Hopkins's and Crocker's estates had already been settled; that left two—his and Jane Stanford's legacy. He suggested that paying a lot of money for university faculty would soon impoverish the government's share of the estate. But Huntington had underestimated the power of an upper-class lady whose role model was Queen Victoria. A probate judge was the first to support her cause. He ruled that the university's professors were personal servants of Mrs. Stanford and entitled to be paid out of her monthly allowance from the estate, which he set at $10,000 a month.

Jane Stanford then marched on Washington. She spoke to President Grover Cleveland personally. He urged that the federal case be settled and may have even helped to have the Supreme Court rule against his own government in 1896. Two years later, she won. Jane Stanford sold her railroad shares, and the net gain for the new university was $11 million.

The first president of the university, David Starr Jordan, had been recruited by the Stanfords from Indiana University. His tenure (1891–1913) included what he called the "six pretty long years" when the Stanfords' estate and the university were in jeopardy.

When the university opened, the inner quadrangle of classrooms, three engineering buildings and two halls for students were ready. The architecture, a variant of Romanesque with its cloistered layout, sandstone walls, low rounded (half circle) arches and tiled roofs, resembled the dominant California Mission style. The Stanfords, especially Jane, had been strongly and

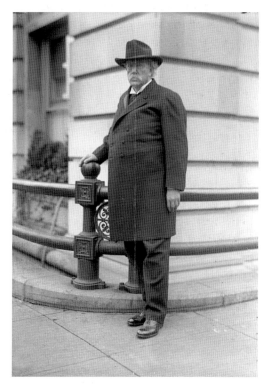

David Starr Jordan, the first president of Stanford University, photographed by Harris & Ewing in 1913. *Courtesy Library of Congress.*

spiritually influenced by the numerous religious centers of learning she had visited in Europe. The result was in a sense a successful blend of the founders' religiosity and the medieval idea of a monastery as a cultural and educational center.

In 1903, Jane Stanford gave her fiduciary power to the university's board of trustees. She was elected, however, as its first president and retained a large measure of control over its affairs, including an academic scandal, the Ross Affair. Edward Ross, a professor of economics, opined on contemporary issues, both within and without the university's sandstone walls. Although he denied ever saying it, "A railroad deal is a railroad steal" was identified with him.

Jane Stanford eventually forced Ross to resign. Because of this blatant interference with academic freedom, Stanford history professor Burt Estes Howard made in his classes what he called "as earnest a protest against interference with academic freedom as I was capable of making." Within six months, he, too, was asked to resign.

The overwhelming majority of students and faculty seemed to support the pressure to force Ross and Howard out. But as Edith Mirrielees, Stanford creative writing teacher and campus historian, wrote years later in her (virtually) official history of Stanford, such blowups of campus opinion have a way of unsettling a place:

> *Outside of classes, nerves went raw. Four-fifths of the faculty might…*
> *be agreed as to the rightness of Ross's dismissal, but one of the one-fifth*
> *might be the neighbor next door, argumentative, uneasy, stiff with a sense*
> *of moral superiority.*

There was, she concluded, "discomfort and emotional weariness and a readiness for grievance."

Edith Mirrielees may not have intended her words to apply to Lamson and his university peers, for she never referred to the Lamson trials in her history. But she wrote it while living in Lamson's house at 622 Salvatierra Street. And she never doubted his guilt.

The Lamsons were married in Memorial Church, best viewed from Palm Drive, the traditional approach road to the university, running west from El Camino Real in Palo Alto. Flanked curbside by palms and then farther away on both sides by enormous eucalyptus trees, Palm Drive leads the visitor directly toward the university's distinctive red tile roofs. Walking or driving the length of Palm Drive, the visitor is confronted with a dramatic

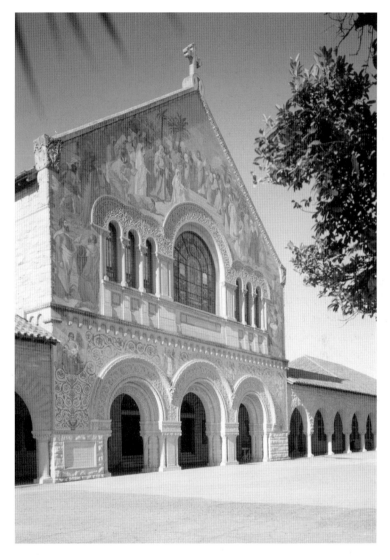

Stanford University Memorial Church, front façade (viewed from the east) with mural, *Christ Welcoming the Righteous into the Kingdom of God. Courtesy Library of Congress.*

view of the façade of Memorial Church, with its colorful mural suspended as if in the air above an oasis.

Following Queen Victoria, her spiritual mentor in the worship of the dead, Jane Stanford decided that her equivalent to the Albert Memorial in London would be a church at the center of her son's university. Although at

her husband's death in 1893 she dedicated the church to him, the financial difficulties of its first decade occupied her until 1903, when she spent $1 million (more than $12 million today) on the church.

Although the large mosaic mural resembles the scene of Christ's Sermon on the Mount, it is actually Jane Stanford's version of Matthew 25:34, or, as Stanford's church historians call it, *Christ Welcoming the Righteous into the Kingdom of God.* For this and all the mosaics of the church, Jane Stanford commissioned the Venetian mosaic studios of Antonio Salviati to work for three years on-site. The designs were created by Antonio Paoletti, who would first ship his watercolor sketches to California for her approval before the mosaics were begun. She closely controlled how this memorial to her husband would look.

The Stanford Memorial Church was eclectic in inspiration and in design. Although the Stanfords were Episcopalians, their travels in Europe and their love of the art and architecture of the medieval cathedrals made them, especially Jane, prone to a very decorative Catholic vision of what a church should be.

The mosaics and stained-glass windows with dramatic scenes from the Old and New Testaments were flanked with numerous angels. Supplementing these were carved stone messages from Mrs. Stanford's diaries or commonplace books. One of Jane Stanford's messages—under the stained-glass window depicting the raising of Jairus's daughter—had a touch of prophesy:

> *Events are messengers of either Divine goodness or justice. Each has a mission to fulfill, and, as it comes from God, accomplish it in peace. And, in sending them, the good Father also sends means by which they may be endured—perhaps averted. Remedies in sickness, Love in trouble, Comfort in weakness, Renewed hope in disappointment, Tears in sorrow, Smiles to follow tears.*

Above this message, which cheerfully contradicts itself, Christ reaches out to touch Jairus's daughter, who appears to be in a deathly sleep. Her father kneels at her side, waiting for a miracle that comes even though, Luke tells us, Christ had asked the girl's parents to keep the miracle to themselves. Of course, they cannot.

The most dramatic mosaic in the south wall, *The Garden of Eden*, depicts Adam and Eve. It could have been called the *Expulsion from the Garden*, for it is an imitation of Masaccio's famous fifteenth-century painting in Florence's

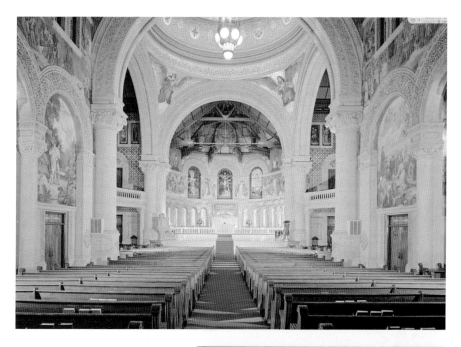

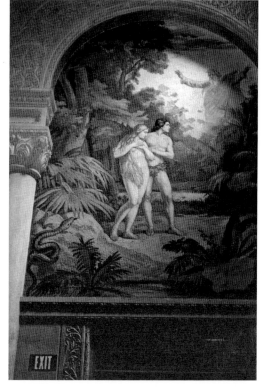

Above: Stanford University Memorial Church, interior with south wall. *Author's collection.*

Right: *The Garden of Eden*, mural on the south wall of the Stanford University Memorial Church, based on Masaccio's Florentine painting, *Expulsion from the Garden of Eden. Author's collection.*

Brancacci Chapel, where Adam and Eve, naked (especially Adam), are not in the Garden of Eden but already on their way out. It was the first fall from grace.

David Lamson and Allene Thorpe were favored children of the university, and their choice of its Memorial Church for their wedding was inevitable. Lamson was class of 1925, Allene, 1926. Attractive and popular, both were active in numerous undergraduate acting and writing societies as well as editors of various Stanford publications.

Lamson had graduated from Palo Alto High School, where he was student body president. At Stanford, he was a history major, eventually graduating with honors. He had written a show and also acted for the prestigious Ram's Head society. He was on the editorial board of *The Quad*, the yearbook, and other campus publications. After graduation, he took a job as sales manager for the Stanford University Press.

Allene Thorpe's career at Stanford was remarkably similar to Lamson's. She was an active member of a sorority and was woman's editor of both *The Quad* and the *Stanford Daily*. She, like Lamson, was known on campus as a creative writer. On the morning of her wedding, June 18, 1928, she received a master's degree in journalism from Stanford. She was executive secretary of the local YWCA. She had the reputation of being one of the best-dressed women on campus; at Stanford, with a significant array of quite affluent undergraduates, that was indeed a distinction.

The ceremony took place in the church at 7:00 p.m. Unfortunately, the wedding announcement in the *Palo Alto Times* the day before

Allene Lamson, undated photograph. *Courtesy Associated Press.*

34

had specified 8:00 p.m. As a result, a number of wedding guests arrived at the church an hour late and missed the ceremony. A reception was held after the wedding in the couple's first home, on Bryant Street in downtown Palo Alto, where, until the wedding, Allene's parents had stayed since their arrival from Lamar, Missouri, her hometown.

Although the Lamsons and doubtless many of their bridge-playing friends were humanities students, the future of Stanford and Silicon Valley had already been set in place by an engineer, Lee de Forest, and co-workers from the Federal Telegraph Company. With financial support from some Stanford colleagues, they had managed for the first time to have a vacuum tube they named the Audion amplify a signal. Like a number of Silicon Valley stars of later years, they were working in a cottage on Emerson Street in Palo Alto in 1912, quite close to the Lamsons' first home.

THE DEATH OF ALLENE LAMSON
ON THE STANFORD CAMPUS

Salvatierra Street is a ten-minute walk from the Outer Quadrangle of the central campus. Although this quad was a core element of Olmsted's ambitious plans for the university, the streets that contained faculty housing southwest of it were less important and, with a few minor exceptions, utilitarian even by the California standards of the 1930s.

Just two streets south, Alvarado Row, running parallel to Salvatierra, had the first houses built hastily in copycat designs to accommodate the faculty families who arrived with Stanford's first president, David Starr Jordan, in 1891. Houses on Salvatierra followed, mostly in the 1920s.

Faculty at first leased the new homes from the university, but Stanford's official history admits that "the relationship between the faculty as tenants and the university as landlord had always been difficult." Eventually the university offered both faculty and administrators low-interest loans, but the mortgage specified that the house could not be sold to non-Stanford employees without the university's consent. The land could not be sold, period.

The Lamsons bought 622 soon after their marriage. It was a small, vine-covered cottage with the Mission-style pink adobe tile roof characteristic of Stanford's buildings. It was a one-bedroom house, with a small maid's room used as the nursery, where the Lamsons' daughter, Allene Genevieve, born in 1931, slept. Halfway down the hall, between bedroom and nursery, was the small bathroom where Allene Lamson died.

When he became the sales manager of Stanford University Press, David Lamson had considerable literary experience, but the press did not publish

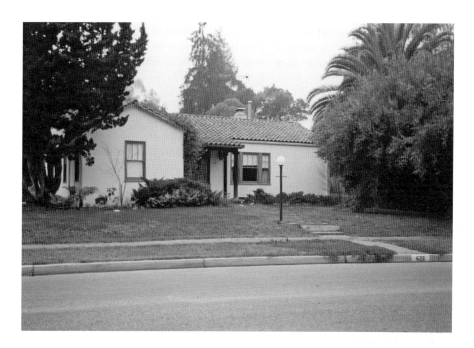

Above: David Lamson's home at 622 Salvatierra Street, Stanford University, photographed in 1988. *Author's collection.*

Right: Floor plan of 622 Salvatierra Street, Stanford University. Designed by Emily Taylor, based on plan published in the *Palo Alto Times*, September 9, 1933. *Author's collection.*

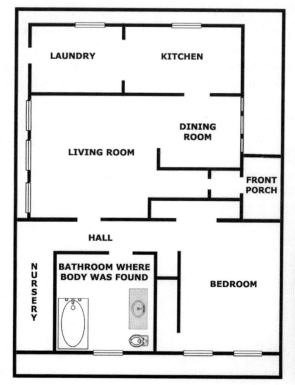

fiction or poetry. In fact, it was less like a present-day university press than a general commercial publisher. It was expected to make money or at least break even. Like many businesses in the early years of the Depression, the press was under financial stress.

As a means of getting the press solidly in the black, Lamson had proposed two series of practical books for 1932–33. Each title would sell for one dollar. The first series, edited by Stanford's president, Ray Lyman Wilbur, would give advice to public school administrators on school "economies." The second series would offer advice on part-time gardening and other aspects of domestic science, directed toward those, especially housewives, who needed to raise food cheaply and save money during the Depression.

Before Memorial Day 1933, Lamson was in the midst of a complicated publishing scheme for the second "home and garden" series. The *Sacramento Union* newspaper would publish excerpts on a page paid for by advertising by seed merchants. These merchants, in turn, would sell the books in their stores, supplied to them at a discount. A former classmate and friend of Lamson's, Sara Kelly, who had been working for the *Union* in advertising sales, was to be the liaison between Lamson and the newspaper.

The Lamsons, like many other Californians, also had their own part-time gardening scheme at 622 Salvatierra. They had fruit trees and artichokes and other vegetables in their garden. David serviced their front lawn with a portable sprinkler. On the morning of Allene's death, on Memorial Day, David had fetched tools and his boots and started doing yard work. He had also started a small backyard fire to burn raked leaves and other debris. The baby was away with David's sister for the weekend.

At ten o'clock that morning, while working in the yard, David Lamson's life became a case. His neighbors had observed his suburban behavior without any surprise. Over their connecting fence, Lamson chatted with Helen Vincent, who had just come out of her garage, a few feet from his, to wash her car. Their neighbors across the street—Stanford journalism professor Buford O. Brown and his wife, Hallie—had not seen Lamson outside. Other neighbors had seen the smoke from his little fire, and one, Mrs. Bailey, said that she detected a "meat odor" in the air.

Lamson's fire-tending was interrupted by Julia Place, a real-estate agent, who told Lamson that her clients, Mr. and Mrs. Alfred Raas, wished to look at the house as a possible summer rental. Lamson had no shirt on. The yard work, despite the early morning start, had been hot work. He had thrown both his outer shirt and an undershirt over a lattice-type fence near the fire. Lamson directed Place to the front door and told her he would meet her there shortly.

David Lamson's front porch at 622 Salvatierra Street, Stanford University, photographed in 1988. *Author's collection.*

As she left, he put on his outer shirt, went into the house through the back door into the laundry and exchanged his boots for white tennis shoes. Mrs. Place, having called only Mrs. Raas up to join her, waited patiently at the front door for him to reappear. But first they heard a strange cry from within. Lamson threw open the door and said, "My God, my wife has been murdered!" Like every utterance in this case, this one was open to dispute. Mrs. Raas thought he said, "My God, my wife has been killed!" It was, at least, one of the few statements in which only *one* word was contested.

Place also remembered Lamson shouting, "Get the police and find the murderer!" or something close to that. The prosecution would later stress that Lamson used the word "murder" twice within minutes of seeing Place.

Both Place and Vincent acknowledged how cheerful and relaxed Lamson was while working in the backyard and how distraught he was minutes later. What happened, however, in those few minutes would take three years of court battles to settle. For some, it was never settled.

Lamson's version of the events really began the night before. The Lamsons had visited the home of Dr. and Mrs. Wright, where they spent, the Wrights said, a pleasant nonalcoholic evening playing bridge. It was the

second night in a row of bridge for these avid players. The Wrights testified that the Lamsons appeared not only friendly to each other but especially caring. They drove home about eleven o'clock.

Allene Lamson then complained of indigestion. As she had been working hard that week, "one of us suggested, I don't know who," Lamson testified at his first trial, that he sleep in the nursery. Lamson placed his bathrobe and work clothes for the next day's garden chores in the living room and waited ten or fifteen minutes until he was sure Allene was asleep. He then changed into his bathrobe and slippers, checked on Allene and went to bed.

David said that, at about three or four o'clock in the morning, Allene cried out for him, and he went to see what was the matter. She complained of a pain, which Lamson assumed was from a recurring problem of "gas on her stomach." After rubbing her back, he gave her a glass of lemon juice. Following their usual custom when she woke up at night, he brought her something to eat—hot tomato soup and a cheese sandwich. He rubbed her back again, and she went back to sleep.

Lamson went back to bed about four and slept until six o'clock. He fixed himself breakfast, put on his work clothes and went outside, where his neighbors first observed him working in the garden between eight and nine o'clock. He started his fire about eight o'clock.

David testified that at nine o'clock he came back in and prepared a breakfast tray for Allene: shredded wheat again. He began filling the bath for Allene. He woke her up, kissed her and told her that her bath was ready. She put her hair up in braids first of all. Then she went to the bathroom with Lamson, who helped her into the bathtub. Because he was concerned about his fire in the yard, he told her about the breakfast and left her.

Once outside, he left the backyard only to turn on the sprinkler on the front lawn. He chatted with Miss Vincent, and then Mrs. Place arrived. While Place went to the front door to contact her clients, Lamson went into the laundry room, having changed his boots for sneakers. He picked up his robe, slippers and pajamas. David remembered having his work gloves in his hands at this point.

The southern end of the living room has a doorway into the hall. Just a step inside the hall brings one to the bathroom, the door of which swings in. Once in the hall, all David could remember seeing was the presence of blood at the bathroom door. The next thing he saw was Allene lying over the side of the tub. He began to lift her body to himself, but he "knew" or "felt" that she was dead. He dropped her, and she slipped back into the water. He reached in and pulled her up again, this time placing part of

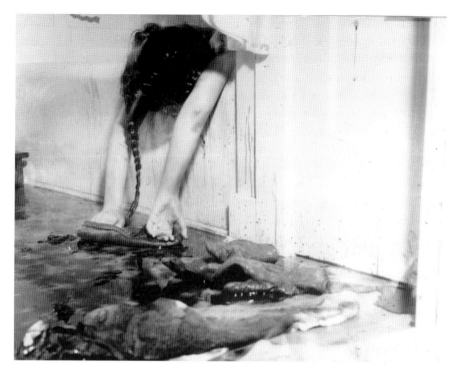

Allene Lamson's body in the bathroom of 622 Salvatierra Street in May 1933. *Courtesy Special Collections, Stanford University.*

her body so that "she would not be in the water, so that her head was over the edge of the tub."

He rushed to the front door, without a shirt on, appearing to be, according to Place, in a "terrible agitation." Lamson had trouble remembering what he did or said in the next half hour. What he did remember is being in the bathroom again with Allene when Hallie Brown, the neighbor, came in and led him out to the patio. He felt "awfully cold"—in shock, as we would say today. His recollections of various people, including his sister, Dr. Margaret Lamson, and deputy sheriffs arriving and talking to him, were "hazy." He probably dropped everything he was carrying in the hall—pajamas, bathrobe, slippers and his work gloves.

At this point, the deputy sheriffs' recollections and Lamson's begin to overlap, except for a number of statements they attributed to David that he denied ever having said. For various reasons, the deputies came to believe that Allene was murdered and that David was the murderer.

41

4.

DAVID LAMSON:
WHY DID YOU KILL HER?

Why? Perhaps it was wishful thinking, but Deputy John Moore thought he heard Lamson say, "My God, why did I ever marry her?" And he heard Lamson's sister, Margaret, reply, "David, don't say that." All this was marginally suspicious, depending on the way these sentences were said. If they were said at all: Margaret Lamson and Hallie Brown denied that they had been spoken. They were not, in any case, particularly homicidal remarks.

With a predisposition to believe in murder and with blood on Lamson as a ghastly sign of involvement, the deputies discovered supporting evidence. Lamson had a mark on his forehead and some scratches around his face, suggesting to them that he had been hit or scratched during a struggle. (The mark was actually a scar.) They soon figured out that Lamson had slept apart from his wife and that her sanitary napkin in the bathroom had no blood on it.

Was it male ignorance of female mysteries that led them through the next few steps in reasoning? She was not having her period, yet she was fooling her husband so he wouldn't sleep with her; having discovered her trick, he struck her.

Within the hour, Lamson's immediate fate was sealed. Deputy Sheriff Howard "Hangman" Buffington arrived and in short order had interrogated Lamson with the skill that had earned him his nickname. He asked Lamson

what he had to drink that morning…and the night before. Lamson recalled saying that he had had orange juice.

Buffington then came right to the point. Why did you kill her? Lamson denied it. Buffington said that they could prove he did, and in any case, he was obviously "sick, brain sick." Lamson testified that Buffington said, "Dave, we know you killed her; we know how you killed her; but what I don't understand is why you killed her."

This fabulous technique had already given Buffington some status in law-enforcement circles. Lamson, unfortunately, did not take him seriously. Perhaps Lamson was falling through a crack in town-gown relationships or, to put it another way, was unaware of some very serious issues of class dividing Stanford from the rest of the Santa Clara Valley—the university elite meets the county good ol' boys. The prosecutor, for example, later praised these deputies for arresting Lamson: "They did not care who he was or where he came from, but brought him into jail."

Whatever the reason, Buffington and others believed they had their man. Their job now was to gather the evidence that would eventually convict him. A few pieces of evidence fell neatly into place. Stanford traffic officer Gordon Davis found a nine-inch piece of pipe and some cloth-like material in Lamson's little bonfire. Then there was the unsoiled sanitary napkin.

Buffington asked more leading questions about Mrs. Lamson's menstrual cycle. He assumed that when Lamson told him that his wife was "not feeling well last night," what Lamson really meant was that she was having menstrual problems. Buffington declared that Lamson was being tricked by his wife; why would she take a bath if she was having her period? This brief tragic farce might have ended when Lamson pointed out that the napkin was unsoiled: "My wife was not in that condition."

But Buffington had a one-track mind. How many times had Lamson and his wife slept apart? Had they talked about "sex matters" the night before her death? What did she have on when Lamson led her to the bathroom for her bath? More tragic farce: Lamson told Buffington that "she had no clothes on." Buffington assumed that this meant she was naked. What Lamson meant, he later testified, is that he didn't think of her "nightgown as clothes."

The importance of Buffington's interrogation this first hour cannot be emphasized enough, for almost every factoid he deduced from his observations of the scene or thought he had extracted from Lamson was later used decisively in the prosecution's case against him. For example, Buffington was very concerned about the blood on Lamson's pajamas,

bathrobe and slippers. He wanted David Lamson to account for that blood. Lamson could not.

Buffington concluded that blood from David's *murdered* wife got on these garments and slippers much earlier that morning, since Buffington found them in different locations of the house. Yet photographs of the bathroom show watery spots of blood on the door and near the wall, indicating that Lamson rushed from the bathroom after his terrible discovery. Lamson's

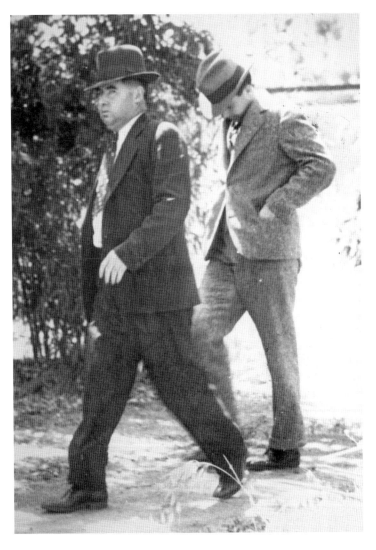

Lamson with "Hangman" Buffington. Date unknown. *Courtesy History San Jose.*

inability to account for his exact movements after he discovered the body weighed heavily with Buffington and the other deputies.

And then there was the matter of the bloody footprints. Lamson had tracked blood in the hallway and elsewhere. If his story was to be believed, these footprints were made after he discovered his wife in the bath. The deputies scrutinized these footprints and decided that they revealed a pattern of action inconsistent with Lamson's spontaneous discovery of his wife's body. Since they had made some of these footprints themselves, the mind reels at their objectivity and confidence.

By 11:00 a.m., the house and back patio had filled with people. Lamson was on a porch swing in the back of his house with his sister and Hallie Brown, crying and repeating, "My God, who could have done such a thing?" He also said, witnesses later reported, "How could anyone do such a thing to a lovely girl like Allene who never harmed anyone?" His bloody outer shirt had been removed, taken by one of the deputies, and he was given a shirt with a green stain to wear by Hallie Brown. He left all his wet and bloodstained clothes in the nursery.

Deputies, local police officers, the undertaker and numerous other people—friends, family and neighbors—were tracking through the house. If it were a crime scene, it was contaminated beyond belief by any standards of police procedure. When Frank Hapgood, the Palo Alto undertaker, arrived, he was instructed by Deputy Sheriff Gordon Davis to tidy up; whereupon he wiped blood marks from both the outer rim and back of the washbasin until he was told to stop. Even by the standards of the 1930s, however, so many people were involved and in contact with potential evidence—bloodstained surfaces, bloody clothes and sheets spread about—that it would tax the ingenuity of both defense and prosecution to explain what actually went on that morning.

The prosecution, however, tried. And it succeeded, especially during the first trial. David Lamson later said that the sheriff's deputies—Buffington, Hamilton and Moore—accused him of murdering his wife within *ten minutes* of their arrival.

Lamson may have returned once to his garden at 622 Salvatierra Street, but never to Memorial Church. He had been expelled from paradise.

Bill Sykes Beats Nancy to Death

Within days of Allene's death, Stanford policemen roped off Salvatierra Street because of the volume of drive-by spectators. The private service for Allene at Palo Alto's Roller and Hapgood funeral chapel was held a week after her death, without David Lamson's presence. Sheriff Emig cited the possibility of Lamson's "physical or mental breakdown" at the sight of his wife's coffin and of some kind of "mob" demonstration outside the funeral home as his reasons for keeping David safely locked up in San Jose. He had also received letters threatening Lamson's life.

As it turned out, the only mob was the "army" of news reporters who were forbidden entry to the Roller and Hapgood funeral chapel for the private ceremony for Allene, arrayed in her wedding gown and wearing her engagement and wedding rings. Charles Gardner, the Stanford chaplain who married the Lamsons, led her funeral service. Allene's brother made arrangements to accompany her coffin to her hometown, where she would be buried in a family plot. He said he had not decided whether to return for David's trial, as he and his parents believed in his innocence.

Lamson, despite his pleas to have one more look at his wife's face, spent the funeral hour in a darkened office of the chief jailer, who allowed Lamson to leave his cell for a symbolic vigil.

As bizarre rumors spread, Lamson's next ordeal was his preliminary hearing before Justice of the Peace Grandin H. Miller. Ironically, the defense encouraged stories that included an unsavory-looking prowler peeking in the Lamson bathroom window at Allene's naked body. When she saw him, she took

fright, screamed and tripped. It was an attempt to tap into the local discontent about vagrants who walked to Palo Alto via the dry San Francisquito Creek bed, slept on its banks and panhandled throughout the streets of the city.

Most of the rumors, however, fed the prosecution's appetite for a scandalous murder trial. The Hearst newspapers of San Francisco announced that Palo Alto chief of police Howard Zink knew that the Lamsons quarreled the night before she died. Although Zink denied this particular rumor, it reappeared as part of the prosecution's eventual case against Lamson.

Delores Roberts, the maid and baby Allene's nanny, had to deny that there had ever been a love affair between Lamson and herself. Furthermore, she asserted that David and his wife were free from jealousy and did not quarrel. The sheriff then announced dramatically that Lamson had killed another person, but it turned out to be a shooting accident when he was thirteen. Lamson's prosecution in the press had begun.

For Yvor Winters of Stanford, David Lamson's most energetic defender, the rumors were especially disheartening:

> Lamson's neighbors, for the greater part, and in spite of the notorious corruption of Santa Clara County, are unwilling to lift a hand in his aid or an eye to examine his case, and they are to a surprising degree the dupes and even the organs of gossip.

Compounding Lamson's problems was an attractive woman who demanded to see him at the San Jose jailhouse. It was Sara Kelly. Sheriff Emig, she said, had given her permission to see Lamson. "Is that so?" Emig was heard to ask. "Well, I am Emig, and you don't get in." She did not realize the problem she was creating.

The prosecution, based on Sheriff Emig's investigation, created a murder scenario: a jealous husband—Emig believed he had a Jekyll-and-Hyde personality—beat his wife to death with a pipe. The county pathologist, Frederick Proescher, said that her injuries were neither self-inflicted nor accidental. That left only one person who could have killed her. At the first hearing, Justice of the Peace Miller accepted this scenario in toto, ordering Lamson bound over to superior court to stand trial for murder.

Allene's father initially believed David innocent but that an accident was unlikely. Either during the hearing or shortly thereafter, the Thorpe family began to regard Lamson as the murderer. They began proceedings to adopt the baby and arranged for Allene's brother, Frank Thorpe, to sit in with the prosecution team when the trial began.

More trouble for Lamson developed when he tried to assemble a defense team. Edwin Rea was his first and primary attorney, but either Rea or Lamson or both decided that they needed a more impressive presence in the courtroom. Two leading candidates for this task were prominent local politicians and lawyers: Louis Oneal, whom family members and friends mistrusted; and John McNab, who was known for his oratorical skills and who was a friend of Lamson's family.

Both were touted in the press as important breakthroughs for Lamson. Both soon bowed out after making initial statements attesting to their belief in his innocence. The exit of two such prominent local figures, however, created an impression that Lamson's case was not looking good. Oneal was even quoted as saying he would take the case if he believed Lamson was innocent.

When Oneal, the most influential political figure in the county, then announced he was not taking the case, many thought Lamson guilty. Oneal secretly asked for $45,000, Winters wrote to a friend at the time—an impossible figure for the Lamsons to meet.

It turns out that Oneal was more than just a powerful attorney. He began his career leading the Santa Clara County law firm that acted as the shill for the Southern Pacific Railroad, specifically squashing any lawsuits from victims of railroad grade-crossing accidents. He became the preeminent county boss, handing out patronage jobs and controlling things behind the scenes. Emig was his favorite lackey.

Oneal held an open house for politically important allies and friends every Sunday in his ranch in the hills above Los Altos. He, in turn, answered directly to Governor "Sunny Jim" Rolph. The district attorney in Lamson's case, Fred Thomas, was an Oneal protege, having begun his law career in Oneal's firm.

At first, Rea tried to make a virtue out of this politically charged mess by announcing that he would do all the work himself, so convinced he was of his client's innocence that it would be no problem for him to do so. Eventually, however, he took on Maurice Rankin.

Lamson's defense team did acquire a not-so-secret weapon: E.O. Heinrich, the "Sherlock Holmes of Berkeley," who believed in Lamson's innocence. Heinrich's scientific reputation made him a successful expert witness in hundreds of cases, almost always on the side of the prosecution. And he virtually never lost a case.

Solving three very difficult cases made his reputation. By studying three Indian dialects and mastering the intricacies of typewritten letters, he unmasked an American participant in the Hindu-German Conspiracy

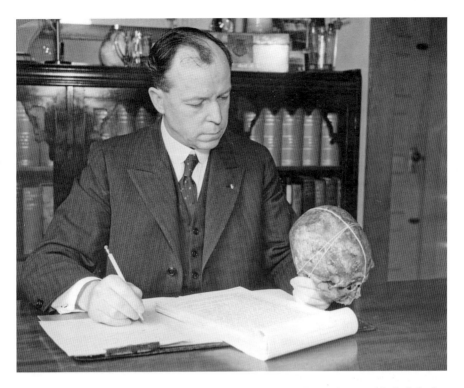

E.O. Heinrich, professional criminologist and key Lamson defense witness, with skull, in the 1930s. *Courtesy Special Collections, Stanford University.*

during World War I. In the 1921 kidnapping of a San Mateo County priest, Heinrich concluded that a master baker had committed the crime by testing the ransom note. Two years later, when the failed holdup of a Southern Pacific train in Oregon left four railroad men dead, Heinrich's examination of a pair of discarded soiled overalls with pockets full of debris led police to a left-handed lumberjack who had worked recently among the fir trees of the Pacific Northwest.

Although Heinrich had once been chief of police of Alameda, near Berkeley, he became a University of California professor specializing in criminal investigations, pioneering the use of microscopic bullet comparisons. In 1931, he re-created an accident scene for jurors, using chemical analyses as well as miniature cars, to track a drunk driver. In this case, he had been perhaps too right. After three days of cross-examination, the defense lawyer for the drunk driver asked him: "Professor Heinrich, have you ever been wrong?" "No," was his reply. "I base all of my conclusions on science, and science, you know, is never wrong."

What made Heinrich's scheduled appearance for Lamson so unusual is that Heinrich almost never appeared for the defense. An interviewer once asked if he would only testify for the prosecution. "Glad you brought that up," he told the man. "Let me get my records—case 863." He then explained at length how he had once before testified for the defense—two boys wrongly accused of killing a man. But this was a rare instance, the exception to prove the rule. Lamson was to be the next major exception.

Judge Syer's court in San Jose in 1933 was probably no better and no worse than many such county courts across the land. But Winters understood the situation in an extralegal context. He told the *Stanford Daily*: "The prosecution in the [David Lamson] case is a very corrupt group. They are typical representatives of Santa Clara County government which is thoroughly corrupt."

Of the spectators in Judge Syer's court on opening day, 90 percent were women. They apparently did not behave well, for there were reports of struggles for the few seats available in the courtroom. One woman, protecting an elderly friend from the rush in the hallways, was herself knocked down. Hundreds unable to get in lined up outside the entrance of the county jail to see Lamson led to the courthouse by Emig and Buffington.

Lamson's first trial began in August 1933 and lasted but three weeks. The prosecution and the press treated the case as a direct result of a "love triangle." Lamson had a mistress—Sara Kelly —in Sacramento. He visited her, bought her flowers at least once and was seen at her apartment and at a number of restaurants with her, including a breakfast occasion. To gain his freedom, it was argued, he murdered his wife.

Some witnesses recalled these meetings. But much harder to explain away were sheets of paper with poems in Kelly's handwriting found by detectives in his desk drawer. The prosecution implied that he was hiding them, of course. The poems were read out loud as examples of actual realized experience between Lamson and his friend, not an imagined narrator and an imagined lover. In short, because Lamson *had* love poems, they must have been addressed to him.

They were not great shakes as poems, but they were explicit enough to do Lamson in, since they were both about a love affair or relationship from afar, presumably from Sacramento to Palo Alto. The first poem read:

> *Life is such fun, my dear,*
> *That even tho, occasionally,*
> *Across the face of our bright sea,*

Our happiness,
There comes a shadow of
Delay and separation.
Yet, deep in those hearts that worship you,
My dear,
There shines a glow of warm content.

The defense pointed out that this was a creative-writing exercise, since the poet had written across the bottom of the page, "Lousy, but you get the idea. Changed rhythm in mid-passage." This concern for technique apparently did not impress the jurors, who heard this second poem (or, perhaps, the second stanza of the first poem):

If in the days before we meet again,
There shall come into your heart a question,
Any vestige of a doubt that I am yours,
As I know you are mine,
Fear not, my dear, nor is there need to see,
For I shall know ere you
And answer ere you ask.

Kelly's role became problematic. The *New York Times*, the paper with the least sensational coverage, nevertheless always referred to Mrs. Lamson as "young" or "pretty" and the Sacramento friend as a "divorcee." One of Mrs. Lamson's close friends testified that Allene Lamson said her marriage was falling apart, but other friends reported that the Lamsons, with a two-year-old child in 1933, were a happy and loving family.

Sara Kelly told the press that she was engaged to another man who resembled Lamson and that there was no affair. Oddly, she was never called to testify. The prosecution didn't need her; they already had the damaging evidence of the two poems and their insinuations. But the defense never called her, either, and this may have convinced the first jury that they had something to hide.

Adding to Lamson's troubles was a semantic sleight of hand. Frederick Proescher, the Santa Clara County pathologist and one of the prosecution experts, added more circumstantial evidence and tenuous inference by asserting, with a heavy German accent, that "washed" or "washed-out" blood was abundant in the Lamson cottage, implying that Lamson had tried to "wash up" the evidence before he was discovered.

Only after the first trial, during the appeal, did Winters and a colleague establish that the prosecution had been demagogic in their use of a term from medical jargon often rendered as "washed blood." The technical phrase was "hemolyzed blood," blood that has come into contact with water. Allene's death in a bathtub meant that her blood came into contact with water. "Washed blood" did not mean Lamson "washed up" the blood.

Another expert was Dr. A.W. Meyer, a professor of anatomy from Stanford's medical school. He was a surprise witness for the prosecution, having originally been asked to examine the body by Margaret Lamson, David's sister, who herself was a physician and Meyer's former student. He testified categorically that Allene's head had scalp injuries as if her hair had been pulled and a fatal wound from repeated blows by an object like a pipe. His leading role in the medical community and his confident testimony made Lamson's conviction virtually certain.

The final blow was the prosecution's exclusion of Heinrich's testimony. The ace witness was trumped. All his investigations, including the creation of a model bathroom to demonstrate Allene's accidental death, went for nought. Judge Syer ruled that Heinrich's investigation of the scene was too "remote"—that is, long after the fact—and that his proposed demonstrations would be irregular.

During closing arguments, Lamson's defense team argued ineptly, conceding too much. The prosecutors were ruthless, making assertions they had never proved. They shamelessly swayed the jurors with special effects that proved that Mrs. Lamson was dead and that iron pipes are dangerous. They did not prove that David Lamson killed her.

Even the structure of the closing arguments worked against Lamson. California murder trials gave the first speech to the prosecution, two rounds to the defense and the summation again to the prosecution. John Fitzgerald went first. He would be followed by defense counselors Maurice Rankin and Edwin Rea. Deputy District Attorney A.P. Lindsay would then give the last speech the jurors would hear before going off to decide their verdict.

Fitzgerald was ruthless. He displayed the life-sized photograph of Allene's dead body in the jurors' faces. He demanded that Lamson be hanged. In doing so, the jury would be more charitable to him than he was to his wife. At least Lamson could have "a chance to appeal to his Maker." "She had no chance," Fitzgerald shouted. "She was struck down in cold blood."

Fitzgerald raised issues of class and social standing with the jury. Don't be influenced by who Lamson is and where he comes from. Treat him, he insisted, as if he were "lowly and untutored and had no friends."

Disregard especially, Fitzgerald urged, Lamson's sister, who testified that David Lamson had never said "My God, why did I marry her?" In a remark at the end of a trial filled with blood and water, was Fitzgerald conscious of what he was saying? Dr. Lamson would be expected to lie, because "blood is thicker than water."

Fitzgerald didn't bother with any specifics when he dismissed accidental death as a possibility. Since the body had been washed, no prowler could have been responsible. Juror Nellie Clemence reacted to his vehemence with tears. When Fitzgerald asked the jury not to be "swayed with sympathy," David Lamson held his head high, perhaps with a touch of arrogance, a number of jurors later noted. It may have contributed to his undoing.

Lamson's stoicism did not last long. When his defense attorney, Rankin, began to speak, Lamson had to wipe *his* eyes. He swallowed nervously. Rankin's speech had brought out the largest crowd since the opening days of the trial.

Rankin's task was difficult. He had to rebut the prosecution's case, substantiated by expert witnesses, but he could not use Heinrich's theory of accidental death, suppressed by the judge. He had to contest the contradictory motives offered by the state—that Lamson was in love with another woman yet killed his wife when she rejected his sexual advances. Since Sara Kelly did not testify for the defense, his brief was not easy.

Rankin was too generous in dealing with this supposed affair. He admitted that Lamson may have been a "trifle indiscreet" in meeting Kelly at her Sacramento apartment and going to a florist with her. Indiscretion is not a crime. True enough. But with such an emphasis on Kelly, the mysterious lover, even to admit indiscretion may have been a fatal mistake.

Making light of Kelly's poems probably didn't help. "There is no romance or any idea of romance in that poetry," asserted Rankin, repeating Kelly's note about technique. The jury and most listeners heard love poems, not exercises in metrics with love as subject, a distinction routine among the academically advanced students of Yvor Winters, trained in New Criticism, the latest literary fashion. Orchardists did not attend Stanford. Years later, an Apple assembly worker, confronted with Deconstruction, a literary method of disentangling semantic relationships, would be forgiven if "taking a computer apart" might come to mind instead.

Rankin tried to expose the faulty links in the prosecution's chain of circumstantial evidence. He dismissed the pipe as a murder weapon. He criticized Dr. Meyer's testimony because no one could hit another person four times in the same spot on the head. Rankin asserted that Meyer had

for the last twenty-five years practiced not on living men and women but on "corpses, cadavers and skeletons," attacking his professional standing, a risky proposition given his position at Stanford.

Lamson's character was Rankin's best angle. He recalled the testimony of the Lamsons' neighbors, Helen Vincent and Hallie Brown, as well as the real estate agent, Mrs. Place, all of whom said that Lamson's grief after the revelation of the body was genuine. He could not have been play-acting, an allegation derived from Lamson's successful record as an undergraduate and community theater actor.

Rankin tried to get Heinrich's name before the jury by the back door, Judge Syer having closed the front door. Rankin acknowledged that everyone, including Lamson himself, believed at first that Allene had been murdered. Only when Heinrich "entered the case" did the belief that it was an accident take hold.

All of this was certainly true. Yet the very essence of this discussion was damaging to Lamson. It tried to get the jury to accept an argument (the accident theory) that the judge had virtually forbidden them to consider. Furthermore, it dwelt too uncomfortably close to the idea that Allene was in fact murdered and that only Lamson could have done it.

Rankin argued that the officers themselves disagreed on Lamson's movements in the house. He dismissed the notion that Lamson had first gone into the front bedroom, where some bloody wet clothes were found. But it was a matter of great importance, because Dr. Proescher, by using the phrase "washed blood," drilled into the jurors' minds the idea that Lamson had tried to wash up the blood.

By debunking the weak points in the prosecution's case, Rankin missed an essential part of its argument; in fact, we can see in hindsight the defense's entire case: that they had no case at all and intended to hang Lamson because he was the only one who *could* have done it. Thus, the prosecution merely outlined a pattern and hoped that the jurors would accept it.

Rankin saw the pattern, but he was powerless—perhaps even too ethical—to oppose it. The pattern was this: Lamson was frustrated in some unspecified but real way associated with Sara Kelly. He reacted to his wife, in an unspecified but uncouth way, and murdered her. Realizing that his attempts to cover up the crime were hopeless, he staged the acting performance of his life.

Legally speaking, the prosecution could prove only a fraction of this story. During the closing arguments, it found ways to assert the whole thing.

When it was Rea's turn, he began to attack the judge and ignore the jury. He complained that Heinrich had been banned. He complained that

the jury had been locked up. He complained that the sheriff's office had been in constant contact with the jury, providing them with "favors…at the taxpayer's expense."

Judge Syer asked Rea if he believed that the court was unfair, because these matters were the judge's orders, not the prosecution's prerogative. Rea was trapped. He risked losing favor with the jury when he attacked the judge, but he soon made the same mistake as Rankin by returning to Sara Kelly. He conceded that there "may have been…a little flirtation," although Lamson himself had denied it. "Even if there were proof of illicit relations," he stated, "that is not a motive." To suggest that Lamson may have been guilty of adultery was a disaster; after all, this jury would never hear Sara Kelly deny it.

Trying to recover, Rea joked: "If every man in California killed his wife every time he flirted with another woman, how many wives would be left?" The punch line? "I should guess the married women on the jury, the wives of the men jurors and my own wife." No one laughed.

"But men don't kill" because of a flirtation. At this point, the hole he had dug for Lamson could not go much deeper.

He turned to the prosecution's expert, Dr. Proescher, calling him "the most discredited man who ever testified in a courtroom." He ridiculed his attempts to find incriminating bloodstains that fit the prosecution's case against Lamson. He accused Proescher of gross incompetence and even of manufacturing test results: "If Dave Lamson goes to the gallows, Dr. Proescher would have committed murder." The doctor "had a lot of nerve" coming to this trial to testify on such matters as blood spurts, since he was not a "practicing physician." Did any juror realize that E.O. Heinrich's expertise on blood spurting was not based on a medical degree, either?

Rea detailed the difficulties of the prosecution's case. He appealed to the jurors' reasoning powers. How could anyone, he said, figure out how Lamson's clothes ended up in different locations? In any case, there was *hemolyzed blood* on these garments, using carefully and correctly the adjective for blood that has come into contact with water. Furthermore, there was no *arterial* blood on his clothes, because he was not present when Allene's blood spurted. Both of Lamson's supposed statements—"My God, why did I marry her?" and "My God, who could have murdered her?"—were unlikely. Deputy Johnny Moore did not hear, "My God, why did I murder her?" Such a line of discussion could only put some bad ideas in the jurors' heads.

Next up was Lindsay. What he really believed was irrelevant, because Lamson's guilt was always on his lips; how he got the conviction was his

only task. His passionate speech frightened the jury. He brought them Allene dead and very bloody. He showed them photographs of Allene's body taken at various angles. He spoke for six hours, his case entirely circumstantial, his methods histrionic.

Earlier, Rea had told the jury it was easy "to ask for a hanging. But it will be on your conscience, not the district attorney's." Lindsay wanted a hanging. He spoke of Allene's grave, where she was lying "utterly alone, utterly defenseless." For this "defenseless girl" he asked for a "square deal": the execution of her husband.

Blood was his mantra. Neither Dr. Proescher nor anyone on the prosecution's team "wants to put blood where it isn't." He and Proescher lived locally and intended to stay locally. They would not do anything to jeopardize their standing in the community. They would certainly not manufacture evidence, as the defense suggested. "We are not murderers," he added, with conviction.

But the mere mention of expert witnesses apparently triggered something in Lindsay. Calling Heinrich "a professional witness open to hire" and (later) a "hired criminologist," as if Heinrich were some underworld commodity used by the justly accused everywhere, was curious. And a half-truth. Certainly Heinrich was for hire. He was for hire for the most part by prosecutors like Lindsay and very rarely was anywhere but at the prosecution's table as its star expert witness.

Heinrich, whose batting average for the prosecution all over the Bay Area, not to mention nationally, must have been something close to one thousand, was being treated as if he were a feeble pinch-hitter! Lindsay surely knew better. At one point he struck the huge photograph of Allene's body at the spot where the blood was thickest. Later in his speech, he showed the jurors a smaller copy of the same photograph and told them, "That's real blood. There, you can even see Mrs. Lamson's eye shining in the blood, its reflection there." The *Palo Alto Times* reported that the female jurors "shuddered" at this moment. But Lindsay never let up on the blood.

The blood was Lamson's fault. There was blood on the ceiling trapdoor in the hall. Blood on Allene's nightgown and clothes hanging on the back of the bathroom door. Blood on Lamson's shirt, which he said he left in the back bedroom. Blood on the bathmat and towel wedged up against the door. Therefore Lamson had gone back and forth from the bathroom to the front door a number of times. But there was no blood on Allene. (Not true, by the way!) It must have been *washed* off.

The blood, Lindsay concluded, "is against the accident theory." He suggested that Dr. Meyer's examination of the wounds made him "the closest to an eyewitness that we have." Four falls or four blows, he told the jury: take your pick. The accident story was "concocted" by that "professional witness" Heinrich, even though another witness had testified that her father had fractured his skull in four places after a fall. Lindsay had earlier dismissed that testimony: "You can't hoodwink a jury with that kind of thing."

Lindsay liked to handle the exhibits. He held up to the jury's faces the bloody garments. He read from Sara Kelly's poems taken from Lamson's desk. He read from the bills of flower purchases. At the end of his speech, he held up the pipe.

Some discrepancies in Lamson's as well as in Helen Vincent's and Hallie Brown's stories encouraged Lindsay's malice. He accused Mrs. Brown of changing her story to benefit Lamson and even went so far as to accuse her of destroying evidence. In a sinister aside, speaking of Mrs. Brown as if she were a sorority girl gone wild, he said, "We are going to see that that girl gets a square deal."

Furthermore, Lamson "could squander money on another woman, but there is no evidence that he bought his wife even a violet." He held up the nightdress Allene had on the night she died. "Look at that nightdress. It is a cheap one, while he could spend money on another woman."

Lindsay then held up the iron pipe and began to read the scene from Charles Dickens's *Oliver Twist* in which criminal and bully Bill Sykes murders Nancy, his girlfriend. Sykes had been consumed with murderous anger when he suspects (wrongly) that Nancy has betrayed him. The scene unfolds in the novel with two murder weapons, but the assistant DA only needed one. He began to read:

> [Bill Sykes] *freed one arm, and grasped his pistol. The certainty of immediate detection if he fired, flashed across his mind even in the midst of his fury; and he beat it twice with all the force he could summon, upon the upturned face that almost touched his own.*
>
> *She staggered and fell: nearly blinded with the blood that rained down from a deep gash in her forehead; but raising herself with difficulty, on her knees, drew from her bosom a white handkerchief…and holding it up, in her folded hands, as high towards Heaven as her feeble strength would allow, breathed one prayer for mercy to her Maker.*

The assistant DA read these final lines: "It was a ghastly figure to look upon. The murderer staggered backward to the wall, and shutting out the sight with his hand, seized a heavy club and struck her down." He began to bang the iron pipe repeatedly on the rail of the jury box, startling the jurors so much that some of them jumped back in their seats.

"I am not hitting with my full strength," Lindsay told the jury, reinforcing Dr. Meyer's testimony that even a child could have caused the blows to Allene's head. "If there is any doubt in your minds," he admonished the jurors, "take this pipe in your hands and you will get the idea." They dutifully passed it one to another.

The blood on this pipe proves that "circumstantial evidence is impregnable," Lindsay asserted, conveniently forgetting his earlier suggestion that Dr. Meyer was practically an eyewitness. In fact, he now stated, such circumstantial evidence is "better than any fifty eyewitnesses." In pursuit of a hanging, Lindsay had truly lost all shame.

Lamson was a "calm and cool" murderer, playing a role in front of neighbors, family and officers of the law. Never mind that this characterization contradicted the prosecution's earlier estimate of Lamson as having acted in a sexual or angry passion! Lindsay compared Lamson's cool murderous demeanor to Macbeth, forgetting or perhaps deliberately blurring gender, for Lady Macbeth was the one remarkably in control of herself at first.

Lamson's plan, Lindsay suggested, was to clean the body and take it away from the house on the afternoon or evening of Memorial Day. He would have disposed of the body in the San Francisco Bay or in the remote hills that lie between Palo Alto and the Pacific Ocean. For these options, Lindsay offered not a shred of evidence or even a substantiated conjecture.

"We come," he told the jury, "in the name of the people to plead for justice. The officers have done their duty well. You are not going to let this man out of here with blood on his hands." Virtually the last word the jury heard before receiving the judge's instructions was "blood." It was Lindsay's triumphant accent.

Lamson was relatively calm and attentive during Lindsay's diatribe. He stared at the judge, who outlined the four possible verdicts: guilty of murder in the first degree with the death penalty or life imprisonment, guilty of murder in the second degree and not guilty.

Syer specified a very narrow definition of premeditation, stating that planning for a crime can take place "in an instant." He told the jurors the defendant was innocent unless proven otherwise and that they should "distrust" any witness who has been caught out in any false statements.

Lamson's jury with alternates and staff from the first trial, 1933. *Courtesy History San Jose.*

Syer added that circumstantial evidence must be consistent with the hypothesis of the prosecution and that every fact must be proven "beyond reasonable doubt." The jurors are not bound to accept the word of an expert as conclusive but must judge such testimony on their own. No proof is necessary for a given motive.

A better set of instructions for conviction was hardly possible. The prejudicial posturing of the prosecution, the strongest parts of their case (their expert witnesses) and weakest (lack of demonstrated premeditation and the motive) were reinforced.

The jurors filed out, while Lamson joined his sisters in a waiting room. In Palo Alto, baby Allene Genevieve played at the home of Lamson's mother. The house at 622 Salvatierra Street was abandoned for the first time since the trial began. Lamson's family and friends had taken turns staying at the house to keep it in as unchanged condition as possible should it be needed for a jury's visit that never came.

In five hours (including a dinner break), the jury reached a verdict. Lamson's card game (bridge?!) with his sisters and a friend in an adjoining

room was halted. When the verdict of guilty was read, Lamson closed his eyes. After Judge Syer announced that he would sentence Lamson in three days, Lamson collapsed in a nearby room.

Lamson's inevitable death sentence was delayed by a defense motion for a new trial. His lawyers at first offered ten general grounds for their motion, ranging from jury misconduct to "prejudicial misconduct" on the part of the prosecuting attorneys. As information about the jury's deliberations began to leak, they specified their targets. One of the jurors was an unsalaried deputy sheriff and should have admitted that fact when asked if he knew Sheriff Emig or had any connection with the sheriff's office. Forbidden activities such as visits from family or reading newspapers were routinely ignored.

The most spectacular allegation came from one of the jurors, Nellie Clemence, who had voted for acquittal on the first two ballots. Before the third ballot, she was "coerced," she said, into voting guilty. The foreman told her a threatening story about a juror who had "held out" in a recent case of the murder of a policeman. The murderer was acquitted because that juror had been "fixed." Another juror told her, "We are voting to protect our daughters from such fiends" as Lamson. The matron in charge of the jury, Lenora Ghetti (Sheriff Emig's secretary), had whispered to Nellie Clemence that Lamson was an addict whose sister had supplied him with "dope." Furthermore, Ghetti knew that Lamson had already confessed to his lawyers. Ghetti denied all of these stories, but why Clemence would have opened herself up to possible public censure by concocting such stories is unclear.

Other fascinating irregularities were revealed by foreman George H. Hegerich, who said that the jury constructed a model of the Lamson bathroom in the jury room using chairs, desks, maps and charts of the Lamson home and "the big picture of Mrs. Lamson's body in the tub." We all took turns "falling" out of the model, Hegerich said, to see if "we could hit our heads on a wash bowl hard enough to dash our brains out." Hegerich himself was "one of the chief actors," complaining that he was "black and blue all over from falling in ridiculous positions."

Since Heinrich's experiments with falling were not permitted, it is quite odd that the judge did not find the jurors' exertions out of order. Hegerich also said that the jury "practiced hitting" with the pipe and concluded by "plain common sense" that Allene could have been killed in this manner. His remark may have indicated a wholesome respect for common sense. It may have also simply reflected the jurors' weariness with expert testimony and its contradictions.

Rea and Rankin singled out Lindsay's use of *Oliver Twist* as a way of influencing the jury. Curiously, at least for us today, they took no note of his blatant exploitation of the photographs of Allene's corpse or his use of the pipe to drive home the murder blows in the jury's faces. They did not, of course, pick on the use of surprise witnesses, since they were a common feature in trials of the 1930s.

When opposing attorneys Lindsay and Rea met in front of Judge Syer to argue their respective viewpoints, Lamson was all but forgotten as their hostility boiled over in open court. One of Rea's affidavits—on the jury's experiments while deliberating—especially annoyed Lindsay. As well it might: it pointed out the jury's need or desire for demonstrative evidence that Lindsay fought, successfully, to exclude throughout the trial. Lindsay asked aggressively whether this affidavit was based on fact or on "information and belief." When Rea denied that it was based on the latter, Lindsay announced that since it was not based on fact, the affidavit was therefore perjured.

Rea shouted at Lindsay as the judge was leaving the bench for the lunch recess: "You may get away with that with some people but you can't with me." Rea then rushed at Lindsay, swinging. He socked Lindsay square in the face, breaking his glasses and cutting him above the eye.

Despite his reduced vision, Lindsay threw what the *Palo Alto Times* called a "powerful right" to Rea's chin, drawing blood and making Rea "groggy." The court bailiff parted the two men after several minutes of fighting, but they vowed to continue the brawl. "I'm ready for you any time," said Lindsay. Despite the fact that he had already been floored once, Rea replied, "That's all right with me. I can knock the stuffing out of you any time."

What Judge Syer thought of this style of legal contest has not been recorded. The next day, he denied the defense motion for a new trial. He delivered a brief speech about the law being "the last barrier between civilization and barbarism." Laws that "seem stern are often necessities."

He then turned to David Lamson and asked him if he had "any legal cause to show why judgment should not be pronounced." Lamson asked if he might speak:

> *I understand, your honor, that under the law and under this verdict you have no alternative save to pronounce the death penalty. I should like you and the people of this state to know that my conscience is clear before your judgment and the judgment of God. I know in my heart that I have been a good husband to her. I have done her no harm. I am as innocent of her death as you yourself. That is all.*

Judge Syer's speech in return was the formula of doom:

> *It is now therefore adjudged and decreed that judgment of death be, and is hereby pronounced against you, David Lamson, for the crime of murder in the first degree and that within the prison walls of the State Prison of California at San Quentin on Friday, the fifteenth day of December, 1933, you be hanged by the neck until you are dead. And may God have mercy on your soul.*

Rankin jumped up immediately to file notice of an appeal of both the sentence and the denial of the motion for a new trial. He also asked the judge for Lamson to have ten days in the county jail before being taken to San Quentin.

It was up to Sherrif Emig, the prosecution asserted, and despite Rankin's direct plea, Lamson was led away. But it wasn't until ten days later that Lamson was taken to death row at San Quentin.

In retrospect, Winters had understood the problem intuitively. He told the *Stanford Daily*:

> *The prosecution in the case is a very corrupt group. They are typical representatives of Santa Clara County government which is thoroughly corrupt. This was evidenced at the original trial of David Lamson where there was enough perjury to send a good many important officials to San Quentin.*

6.

A Lynching in San Jose's St. James Park

L amson had hoped to be accessible to friends and family at the San Jose jail. His memoir, *We Who Are About to Die: Prison as Seen by a Condemned Man* (1935), acknowledged the unexpected luck in his lost appeal: "Had I been in the San Jose jail a few months later, when the city established its place in the scale of civilization by lynching two men accused of kidnapping, I would undoubtedly have gone with them."

Jack Holmes and Tom Thurmond, two unemployed, working-class men, had kidnapped Brooke Hart, the son of a wealthy San Jose family, on November 9, 1933. Hart, a recent graduate of Santa Clara University known for his pleasant and intelligent ways, had become a very popular addition to his father's downtown department store as a vice-president.

When, just four hours after Hart missed an appointment, news came that he was being held for a ransom, he joined the American "kidnapping epidemic" that seemed to be peaking that summer. The Lindbergh baby had been kidnapped the year before, but the case was still unsolved. So prevalent was the rash of kidnappings that in July 1933, the *New York Times* began keeping a box score: "Recent Kidnappings in America." Numerous states, then the federal government, responded by passing "Lindbergh" laws that prescribed the death penalty for killing or mutilating a victim.

Sheriff Emig entered the case soon after Hart's car was discovered outside San Jose. Joined by the FBI, Emig captured the first of the incompetent kidnappers, whose phone call to the Hart family—from a pay phone three blocks from the sheriff's office—had been tapped. Tom Thurmond was still on

Brooke Hart, son of a San Jose department store owner, was kidnapped and murdered on November 11, 1933, by Harold Thurman and John Holmes. *Courtesy History San Jose.*

the phone when he was arrested. He soon turned in Holmes. Both men signed extraordinarily detailed and chilling confessions that explained their murder of Hart just one hour after they kidnapped him. They had thrown him into the San Francisco Bay the week before their capture.

Emig was obviously aware of the possibility of a lynching. At first he took the two men to a San Francisco jail for safekeeping. When the confessions were released to the press, a front-page editorial in the local Hearst newspaper, the *San Jose News*, articulated the mob spirit:

If mob violence could ever be justified it would be in a case like this, and we believe the general public will agree with us. There never was a more fiendish crime committed anywhere in the United States, and we are of the belief that unless these two prisoners are kept safely away from San Jose, there is likely to be a hanging without waiting for the courts of justice.

To read the confessions of both of these criminals—told to officers in a cold-blooded manner, makes one feel like he wanted to go out and be part of that mob.

For ten days, family, friends, officials and the just plain nosy searched the bay for the body. Strangely enough, Emig decided to bring the two prisoners back to San Jose for their arraignment, in part because a young district attorney of neighboring Alameda County, Earl Warren, threatened to bring murder charges, arguing that Hart was killed in his jurisdiction. When a grand jury met months later, Emig cheerfully contradicted himself. He took them to San Francisco not to safeguard them, he said, but to question them further, because "Holmes had not yet confessed."

The arrest sheet of Harold Thurman, one of Brooke Hart's kidnappers, dated November 11, 1933. His lynching date, November 26, 1933, accompanies the word "deceased." *Courtesy History San Jose.*

When Hart's badly decomposed body was finally discovered on Thanksgiving weekend, Louis Rossi, Hart's friend and fellow administrator at the store, told Emig that the two men were in danger of being lynched. Emig said that it was "impossible" for a mob to break into his jail. Rossi insisted that Emig disarm his deputies as the only way "to avoid bloodshed."

Rossi, after fifty years of silence, finally admitted in 1983 why he knew so much of the lynchers' plans: he had attended several meetings of a core group of ten to twelve men, "from all walks of life, students from various universities, men from various fraternal organizations." They were not classmates from Santa Clara University, Rossi insisted, but were "all friends

Monument to President James McKinley in St. James Park, San Jose, photographed by Lee Russell in 1942 for the Farm Security Administration. *Courtesy Library of Congress.*

of Brooke Hart." Rossi's memory may not have been accurate, since Stanford University *Daily* reporters on the scene emphasized in their articles that week that Santa Clara students as well as Hart's friends were among the mob's leaders. The most famous Santa Clara undergraduate of them all, the former Hollywood child star Jackie Coogan, was up front, and people clearly recognized him.

As word of the discovery of Hart's body reached San Jose, a crowd gradually gathered at St. James Park, just around the corner from the jail. Emig decided that tear gas, not live ammunition, would be sufficient to deter the crowd. He was wrong. In any case, he soon ran out of tear gas.

Two groups formed outside the jail. About two hundred men, many with business suits and ties, were closest to the jail and did most of the work of the attack. At least five thousand to six thousand others (perhaps even more), waiting across the street in the park, cheered them on, surrounding the memorial to the assassinated president William McKinley, with its constitutional proclamation. The leading group used two enormous steel pipes from the post office construction site next door to batter down the stout door to the jail. The lynchers rushed through the building until they came to their targets, one of whom was occupying David Lamson's former cell on the second floor.

Emig and his deputies were swept aside. *Stanford Daily* reporters in the crowd said the officers put up only a token resistance, talking and joking with members of the crowd. Despite the paper's characterization of Emig and "Hangman" Buffington as "secretly glad that mob violence had occurred," they were the only two who suffered concussions, when members of the mob knocked them aside.

The two accused men were taken across to the park, beaten mercilessly and brutally lynched. Thurmond was naked from the waist down, Holmes entirely naked. Parents lifted children up to view the spectacle. Women held burning matches to the kidnappers' feet and taunted them: "How do you like your own medicine?" Police from San Francisco, supposedly summoned by Emig when he ran out of tear gas, arrived hours later. Postcards of the swinging bodies went on sale within days until banned by city officials.

The day after the lynching, Lamson's chief prosecutor, Fred Thomas, announced that he would bring charges against the lynchers if an eyewitness would "identify the ringleaders and swear to a complaint." Only one person from the lynch mob was brought before a grand jury, and even he went free. Another, smaller mob besieged the city morgue the next day in an unsuccesful attempt to seize the corpses for burning.

"THE CONSTITUTION IS A
SACRED INSTRUMENT; AND
A SACRED TRUST IS GIVEN
TO US TO SEE TO IT THAT
ITS PRESERVATION IN ALL
ITS VIRTUE AND ITS VIGOR
IS PASSED ON TO THE
GENERATIONS YET TO COME."

SPOKEN ON THIS SPOT MAY 13 1901.

Left: Plaque of President James McKinley's speech on the Constitution, on the monument to McKinley in St. James Park, San Jose, photographed in 1988. *Author's collection.*

Below: Lynch mob with battering ram at door of San Jose City Jail, November 11, 1933. A second pole is evident behind them. A photographer is at lower left, and tear gas is seen as a cloud above the mob. *Courtesy History San Jose.*

The governor of California, James "Sunny Jim" Rolph, when informed of the lynching, said, in words reported across the land, "This is the best lesson that California has ever given the country. We must show the country that the State is not going to tolerate kidnapping." Rolph added that he was checking on San Quentin and Folsom prisons to see if there were any resident kidnappers he could parole "to the fine patriotic citizens of San Jose who know how to handle such a situation." In fact, California had more lynchings in the 1930s than any other state outside the South.

Reaction to the lynching was extremely varied. A Romance languages instructor at Stanford led her students in one minute of hand-clapping the day after the lynching to honor the "due justice rendered." A professor of history said that, "theoretically," he was "against all lynching, but in this case" he thought "it was justified." Ray Lyman Wilbur, Stanford's president, condemned the lynching and turned to the theme later sounded by Lamson's supporters: both the murder and the lynching were horrible, but what of the "gambling, prostitution and liquor" allowed to flourish locally? "Why not," he continued, "make this the occasion to clean up the general lawlessness of Santa Clara County?"

James Rolph, governor of California (1931–34). *Courtesy Library of Congress.*

But Rolph certainly knew his audience. The Cook County, Illinois coroner announced that "a lynching or two in Chicago wouldn't hurt a thing." The very day of Rolph's expostulation in November 1933, a San Jose crowd again began to form, and some of its members demanded another man just convicted of manslaughter. County authorities moved up his sentencing date and rushed him to San Quentin that same day.

Harry Farrell's definitive narrative of the lynching revealed that the corrupt power structure Lamson's supporters feared had been carefully,

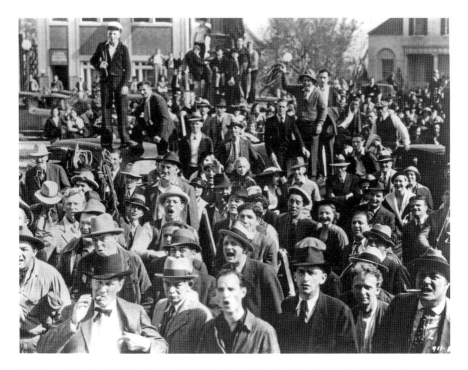

Still from film *Fury* (1937), directed by Fritz Lang. The lynch mob was inspired by the lynching in St. James Park in San Jose in 1933. *Author's collection.*

probably illegally, at work during the lynching. Louis Oneal's ranch had an open phone line to the jail. With Oneal was E. Raymond Cato, the California Highway Patrol chief. Oneal was the governor's friend and, of course, Emig's mentor. Duncan Oneal, Louis's son and a lawyer, was seeing a client at the jail that very evening. He had enough time to lose some money at a craps game that was underway in the booking hall of the jail.

Ray Blackmore, a fellow cop from the old days with Emig on the San Jose police force, did not approve of the crowd pushing closer and closer to the jail. Blackmore warned Emig about this lapse in protection. Emig shrugged it off because, Blackmore believed, of friendship or sympathy with Brooke Hart's family.

Within three years, MGM had released *Fury*, the first American film by the legendary German director Fritz Lang, with scenes closely modeled on the San Jose lynching. Spencer Tracy plays a working-class guy mistakenly identified as the kidnapper of a young girl and pursued by a lynch mob, one of whose leaders boasts that he had just come from a strikebreaking job where "we know how to take care of guys like that."

MURDERERS' ROW AT SAN QUENTIN

David Lamson entered San Quentin's Condemned Row, nicknamed Murderers' Row, on October 6, 1933. His original hanging date, December 15, 1933, was automatically set aside when his appeal was taken up by the California Supreme Court.

He was "confident" that he wouldn't be in San Quentin long. "I am innocent and I'm sure exoneration must come," he told reporters before leaving San Jose for the ride up the Bayshore Freeway toward San Francisco with Sheriff Emig and "Hangman" Buffington. As his open car passed through Palo Alto at the edge of the Stanford campus, Lamson took his last long look at the Stanford foothills. He certainly would have needed his confidence at that moment.

"Hangman," whom Lamson usually referred to as "the fat deputy," had been the chief witness against him; never really lying outright, Buffington just made his words "polluted, blackened, dripping with filth and evil suggestions." The arrival at San Quentin was a relief to Lamson because "it meant getting the case away from the stinking Santa Clara jail, away from politics and prejudice and stupidity, into another level where people used their heads to think with."

His last week in San Jose gave him more time than usual with his mother and child. At first Buffington insisted that a guard be present, but he "failed to detect any strong criminal tendencies in either the child of two or the woman of sixty-eight," Lamson wrote, and they were left alone.

San Quentin State Prison, view from the north, 1930s. *Courtesy Library of Congress.*

As No. 54761, Lamson occupied a cell that, when he stood in its center, was an arm's length in every direction. Imprisoned anarchist Tom Mooney had described a similar cell he occupied for almost twenty years. A single light bulb illuminated the three pieces of furniture in his room: a metal cot, a washstand and a water bucket. Mooney had a slop bucket for a toilet, but Lamson was fortunate enough to have "modern plumbing." The two-foot-thick stone walls were "bright yellow." Lamson's door had four separate locks with a two- by eight-inch slit at the top. He ate "satisfactory" food and found his only relief in using the prison library. He learned, he wrote, that "condemned men are people!"

Lamson was in his cell twenty-two hours every day except Sunday, when he did not even have the usual two hours in the yard to sun himself or to hit a tennis ball against the prison wall. His outgoing mail was censored, and no newspapers were permitted. He learned that Allene's family intended to wage a court battle for baby Allene, then living with Lamson's sister Margaret and her house-mate in Palo Alto.

A Lamson Defense Committee extended the activism of the Lamson Defense Fund. Agnes de Lima, a local writer, published a letter in the *Palo*

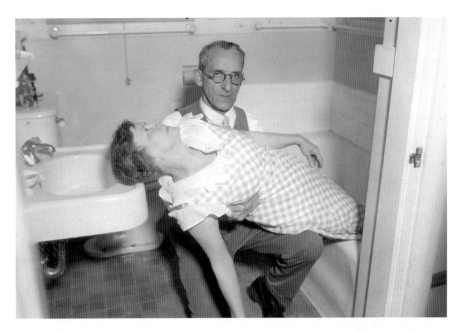

George Weber using his wife as a model to demonstrate the fall of Allene Lamson and subsequent blow of her head against the sink in the bathroom of 622 Salvatierra Street in 1933. *Courtesy Special Collections, Stanford University.*

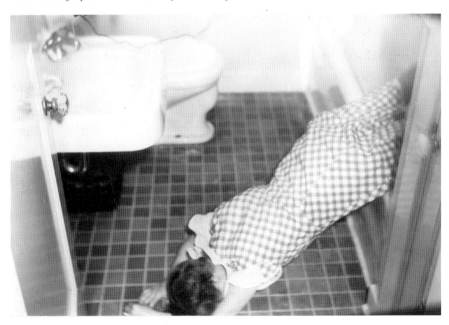

George Weber using his wife as a model to demonstrate the position of Allene Lamson after hitting her head on the sink in the bathroom of 622 Salvatierra Street in 1933. *Courtesy Special Collections, Stanford University.*

Alto Times, just four days after the jury's verdict came in. She found fault with the prosecution's tactics: beating the pipe on the jury rail, she wrote, worked "the jury up to mob frenzy." "The public," she concluded, "has had its fill of blood and sensation." Lamson should have a new trial, she concluded.

Lamson would have his chance for a new trial if his lawyers' brief to the California Supreme Court was successful. The defense committee was supported both nationally and locally by doctors who believed Allene's death was accidental. Using E.O. Heinrich's directions, George Weber invited doctors to witness volunteers, including his wife, falling out of the bathtub at 622 Salvatierra. The volunteer "victims" were approximately Allene Lamson's size. Their heads "hit" the sink and ended up in the same position as Allene: half in, half out of the tub.

Additional support came from August Vollmer, who, with Heinrich, was California's other internationally recognized criminologist. *Best Butter*, a Berkeley law students' magazine with a title from *Alice in Wonderland*, stated succinctly that "detective-professor Vollmer has demonstrated to the satisfaction of his criminology class that the convicted Lamson is innocent." Lamson had often compared his situation to the topsy-turvy world of Lewis Carroll's creatures, especially their antic trial scene: "Verdict first, trial afterwards!"

Lamson now had two of the best scientific investigators of crimes in California, if not the country. Vollmer had joined the Lamson Defense Committee and was quoted on its masthead: "The most amazing situation that has ever arisen in American jurisprudence—a man condemned to hang for something that has never happened—and every bit of circumstantial evidence pointing to his innocence." As chief of police in Berkeley, he established the first scientific crime lab in 1905. By 1932, leading professors of law and biochemistry at Berkeley had selected him to head the first university institute for criminology in America.

Ironically, Vollmer and Heinrich were almost always hired by *prosecutors* to testify. When A.P. Lindsay made fun of Heinrich as a hired witness, implying of course that his testimony was for sale, he was being deliberately demagogic, for Lindsay knew full well that it was the prosecutor, not the defense attorney, who usually hired him.

Thirteen months after Lamson took a cell on Murderers' Row, he was saved from the gallows. The seven justices of the California Supreme Court announced that he should have another trial because the state had not established his guilt.

But then Chief Justice William Harrison Waste told reporters extemporaneously that "a majority of the justices feel that Lamson is guilty but that the state failed to prove it." Thus the readers of every newspaper and therefore the potential jurors for Lamson's next trial read that the California Supreme Court ordered a new trial for Lamson, despite the fact that a majority of the justices believed he was guilty.

The text of the full decision favored Lamson and his strategy of defense. Justice John W. Preston argued that the *corpus delicti* had not been proved; that is, there was no proof that a crime had been committed. Furthermore, the reliance on circumstantial evidence was flawed. "The mind is not satisfied," wrote Justice Preston, that the "rule controlling in circumstantial evidence cases has been met as a matter of law."

Lamson did not, Preston concluded, retain the most fundamental right of being presumed innocent "until the proof satisfies the jury beyond a reasonable doubt of his guilt." Preston cited the decision of *People v. Staples* from 1906, in which a doctor, suspected of an adulterous relationship with a neighbor in Amador County, east of Sacramento, had poisoned his wife. Preston noted that the "right of a jury to return a verdict of guilty is not an arbitrary right." The circumstantial evidence must not only support a "hypothesis of guilt" but also be "inconsistent with any other rational hypothesis." Every link in the prosecution's chain of circumstantial evidence was "compatible with innocence." Lamson had not prepared to commit a crime, he had no plan to conceal the body or avoid association with it and there were no bloody clothes missing and no evidence of a struggle.

Lamson's statements supported his claims of innocence. While it is "true that he may be guilty," the evidence for his guilt "is no stronger than mere suspicion." In ordering a new trial, Preston offered a sentence that has haunted such cases ever since: "It is better that a guilty man escape than to condemn to death one who may be innocent."

Justice William H. Langdon agreed, citing his own opinion in a case from Los Angeles just the year before, *People v. Tedesco*. Charles D. Tedesco had been convicted of killing an elderly man by hammer blows to the head on the basis of circumstantial evidence, including elements quite similar to those of the Lamson case. Tedesco's car was found near the scene of the crime, the hammer was from Tedesco's shop and a miniscule stain on the hammer tested positive for blood. Yet Tedesco lost his appeal, despite evidence "purely circumstantial" and "insufficient to justify the verdict of guilty in the first degree."

Langdon also said that Lamson was deprived of his right to "twelve qualified jurors," citing *People v. Le Doux*, a Stockton case of bigamy in 1909 in which the San Joaquin County sheriff had gathered evidence and witnesses as well as a venire of seventy-five men. Although the sheriff had formed an "unqualified opinion" that Le Doux was guilty, he maintained that he could be impartial enough to sit on the jury as well!

The Supreme Court doubted such confidence and extended its ban to deputy sheriffs, since they act "solely by virtue of the power conferred upon" the sheriff. Sheriff Emig's deputies, no matter how honorary, should not have been sitting on Lamson's jury.

When the Supreme Court's decision was announced, Lamson's lawyers were ecstatic. Every aspect of their trial strategy would be vindicated if District Attorney Fred Thomas was foolish enough to insist on a new trial. Furthermore, if a second trial went ahead without any new evidence, Heinrich, their star witness, would be allowed to testify and the Santa Clara County Court would have to insist on a directed verdict of acquittal based on the Supreme Court's decision, a possibility Chief Justice Waste, however, summarily dismissed.

On the prosecution side, reaction was mixed. The *Palo Alto Times* called Fred Thomas "highly crestfallen" at the decision, but Allene's brother and parents announced that a new trial would only "result in a more positive conviction" because there was "another woman in the case."

Actually, the district attorney could drop the entire matter and free Lamson forever. His sisters and mother seemed to believe that this was likely, expecting Lamson home with his daughter by Christmas if not sooner. In the end, Thomas simply moved to bring Lamson to trial again. He realized, however, that he needed some new evidence.

In the meantime, the Lamson Defense Committee circulated its pamphlet *The Case of David Lamson*, mostly written by Yvor Winters, leading Stanford poet and critic, at a rally at which Kathleen Norris, the best-known supporter of Lamson's cause, would speak. Norris was the most widely published and highly paid "woman's writer" of her era. Alexander Woollcott, her friend and a noted writer as well, asserted that her name on the cover of a magazine would increase its circulation by 100,000 copies.

Norris specialized in realistic but sentimental portrayals of young women, married and unmarried, in unhappy love relationships. Two of her newspaper pieces from the mid-1920s typify her approach, which, like modern soap operas, was always on the edge of the salacious but finished with an easy morality. "Worthless women do not triumph," she told her

readers in 1925; "those women who 'dared all' in their teens" awake to find that their Adonis has turned into "a slightly bald and somewhat stupid man." "Eliminate quarrels and strive for heaven in the home" was her advice in another column the same year; if "unreasoning tirades" dominate mealtimes, confront the raging individual with "absolute and complete silence."

But Norris was no stranger to controversy in public life. She was a prohibitionist, an active feminist, a strong pacifist and eventually an advocate for the abolition of capital punishment. And, despite her statement that she had "no knowledge of those dark forces which fascinate modern writers," she reported on the Lindbergh kidnapping trial in January 1935 for the *New York Times*, with very

The Case of

DAVID LAMSON

A SUMMARY

Prepared by
FRANCES THERESA RUSSELL
PROFESSOR OF ENGLISH
STANFORD UNIVERSITY

and by
YVOR WINTERS
INSTRUCTOR OF ENGLISH
STANFORD UNIVERSITY
REGIONAL EDITOR FOR THE WEST
THE HOUND AND HORN

Introduction by
PETER B. KYNE

*This summary follows for the greater part the briefs for the appeal
by Edwin V. MacKenzie, though some additional
material and analysis are introduced*

★

PUBLISHED BY THE LAMSON DEFENSE COMMITTEE
SAN FRANCISCO, CALIFORNIA
1934

Top: Title page of *The Case of David Lamson: A Summary*, published by the Lamson Defense Committee, 1934. *Author's collection.*

Right: Film poster for *Christine of the Hungry Heart* (1924), based on a bestselling novel by Kathleen Norris about the "new woman" of the 1920s who refuses to conform. *Courtesy Margaret Herrick Library, Academy of Motion Picture Arts and Sciences.*

THE
SILVER SHEET

Thomas H. Ince
Presents
"Christine of the Hungry Heart"
From the famous novel by
KATHLEEN NORRIS

revealing character sketches of the principal figures. She sandwiched the dramatic trial of Bruno Hauptmann in New Jersey between Lamson's first and second trials.

The rally was an ambitious undertaking, with broad support from the religious community, Stanford University and the entire San Francisco Bay area. A pre-rally showing of Lamson family home movies, taken shortly before Allene's death, was designed to show Bay Area clergy "just what happened in the Lamson home as far as possible."

Winters chaired the rally of more than five hundred people at the San Francisco Masonic Temple. He suggested that the tendency of some members of the Stanford University community to continue to "acquiesce in Lamson's conviction" was a "painful and shocking experience" to him. A university "dedicated to critical opinion" should realize that the evidence made his innocence clear.

Norris's speech was quite personal: she confessed that she at first thought that Lamson was guilty. She planned to attend the first trial to gather material, as was her habit, for a future story or article. As one of the "completely biased and the completely ignorant," she was at first driven by a "terrible impulse to hunt down and avenge." After flaws in the state's evidence were pointed out to her, she realized how wrong she had been. Her support of the Lamson Defense Committee's pamphlet was substantial, but now she added a new donation of $800 (more than $14,000 today) to the defense fund.

Although Vollmer could not attend, his speech was nonetheless read aloud to emphasize that "every shred of physical evidence proves that Allene Lamson's death was accidental." The transformation in Lamson's face as he left off his gardening to meet the real estate agent at the front door—from "flushed with exertion" to "ashen"—alone proves his innocence: "such a change no human being can bring about at will."

Lamson's strongest supporters were also busy. A friend gave Winters and his wife, Janet Lewis, a copy of a nineteenth-century classic of jurisprudence, Samuel Phillipps's *Famous Cases of Circumstantial Evidence*, to help them with the key legal concept of the prosecution's case. Lewis went on to adapt three of the chapters into novels, especially the bestselling *The Wife of Martin Guerre* (1941), which established her reputation as a writer.

Winters was one of the few individuals to carry the analysis of Lamson's case beyond courtroom rhetoric. Winters never stopped believing that, regardless of the arena, academic or public, "when a stupid man rises to power he becomes pompous, hypocritical and dangerous." His essay "More

Santa Clara Justice" in the *New Republic* in October 1934 made the Lamson case a national issue.

David Lamson, Winters wrote, was not among "the victims of an economic struggle and of racial prejudice." Such victims can at least "feel themselves to be martyrs to a cause" and believe that "history, at least, will justify them, whether collectively or individually." Instead, he was simply "the victim of an accident and of the irreducible ugliness and irrationality of the human mind."

Winters was an idiosyncratic but socially committed individual impatient with what he would consider the Marxist orientation of the *New Republic*. Nevertheless, he was willing to promote Lamson's cause among the more obviously political cases, in part because he came to understand what he called "the notorious corruption of Santa Clara County." Janet Lewis's own conclusion was succinct; she told her friend, novelist Katherine Anne Porter, that Lamson's jury was "undoubtedly *fixed*" and that "he was railroaded by corrupt county politics."

8.

THE RADICAL LAWYER
FROM SAN FRANCISCO

Prosecutor A.P. Lindsay knocked Edwin Rea down with one punch and made sure Lamson was out, too. He may not have fought fair with Lamson—at least that's what the Supreme Court said—but he intended to send Lamson back to San Quentin.

In the first trial, the prosecution relied on surprise witnesses, expert testimony, attacks on Lamson's moral character and a key ruling by the court (that the jury itself must decide on the accident issue). The prosecution was going to have to allow E.O. Heinrich's testimony about accidental falls and blood spurts. Lindsay came up with an ingenious way to counter this potentially damaging testimony and even use it to his advantage.

The prosecution was also going to have to do something with Frederick Proescher's expert testimony about bloodstains on the iron pipe, because the Supreme Court found it unconvincing. One of Lamson's defense lawyers was overconfident: "We can punch that testimony," he told reporters, "full of holes."

Since surprise witnesses, expert testimony and attacks on Lamson's character were of course not disallowed by the Supreme Court, Lindsay and his team decided to use them again, even add to them.

The defense, on the other hand, could no longer take an acquittal for granted. Lamson's stay on Murderers' Row was too close to the gallows for comfort. The lynching at San Jose and the possible jury tampering reinforced their misgivings about "more Santa Clara justice," as Yvor Winters phrased it.

PAIR MAY AID LAMSON

George R. Harrison, former Stanford professor, and his sister, Mrs. Helen D. Kent, both of Los Angeles, who may aid David A. Lamson if latter gets a new trial, Mrs. Kent declares she fell accidentally in bathtub in which Mrs. Lamson met death while Harrison remembers placing pipe length outside Lamson home when he occupied it before the Lamsons.

News clipping of George P. Harrison and Helen D. Kent, whose affidavits were used by Lamson's defense lawyers in the second trial. Reproduced in *The Case of David Lamson: A Summary*, published in 1934 by the Lamson Defense Committee. *Author's collection.*

Since Heinrich's testimony would be admitted, his views on accidental falls gained more publicity, especially as a result of two new witnesses for the defense. George Harrison, a former professor at Stanford who had lived in Lamson's house, recalled leaving old pipes and similar debris scattered in the backyard during repairs on the cottage. Furthermore, his sister, Helen Kent, had once fallen from Allene's bathtub and hit her head with "a hard blow"

81

against the sink. Her letter about this incident was circulated by the Lamson Defense Committee. Heinrich's testimony on bloodstains, supported by other medical and expert witnesses, threatened the prosecution's analysis of Lamson's movements in the house. And more support for Lamson's moral character would have to be offered.

The biggest change came, however, by replacing Rea as chief counsel for the defense with Edwin McKenzie, who had drafted the brief that won Lamson a new trial. Winters actually contributed substantially to the brief. His wife had begun this task, but Winters said "she wasn't going at it half hard enough."

Rea and Rankin would be McKenzie's associate counsels. Facing the same judge—R.R. Syer—Lamson no doubt needed a new chief counsel, one who had not started a fistfight with the prosecutor and one who had not told the judge (more or less) that he was prejudiced, incompetent or both. And Rea, with a heart condition, was not well enough to take on the task again.

The choice of McKenzie as chief counsel appeared to be a shrewd one. An accomplished and veteran San Francisco criminal lawyer, his radical credentials included assisting Clarence Darrow in the defense of the McNamara brothers, two anarchists accused of conspiracy to commit murder in the bombing of the *Los Angeles Times* building in 1910. He later worked on the Billings-Mooney case.

Warren Billings and Tom Mooney were San Francisco anarchists convicted of murder as a result of a bombing at the pro-war San Francisco Preparedness Day parade in July 1912, when ten people were killed and forty wounded. These known revolutionaries were the target of James "Sunny Jim" Rolph, then mayor of San Francisco, who told the city's chief of police, Daniel J. O'Brien, "to go the limit, and that means going to the root of the anarchistic canker in San Francisco and destroying it."

McKenzie had evidence that Mooney's prosecutor had met secretly with the jury foreman for the case and was in fact a friend of the man. Unfortunately for the course of justice, all the attorneys present at a court session, McKenzie included, ended up in a massive fistfight.

Billings was sentenced to life imprisonment at Folsom Prison, Mooney to be hanged at San Quentin (later commuted to life). During McKenzie's tenure with the Lamson defense, the Billings-Mooney case continued to receive front-page headlines. The two "martyrs for labor" remained in jail until pardoned in 1939.

McKenzie also crusaded against the "professional jury" system then in vogue in many California trials: jurors were picked from a select list of usually

James Rolph, mayor of San Francisco (1912–31), on the left, and his police
chief, Daniel J. O'Brien, in 1923. National Photo Company Collection.
Courtesy Library of Congress.

retired men relied on for their punctuality. In many cases, attorneys on both
sides of a case welcomed them because they knew them well enough not to
have to investigate or cross-examine them. These duties became patronage
jobs, plus the city provided free lunches.

McKenzie went up against a prosecutor who boasted that he would use
such jurors to hang McKenzie's client. McKenzie refused to continue, and
the judge sentenced him to five days in jail for contempt of court. The local
press supported McKenzie: it was one thing to hang Billings and Mooney

with professional jurors, but it was quite another thing to send an important lawyer to jail. McKenzie therefore had solid experience with a potentially corrupt judicial system.

The selection of a public radical like McKenzie reflected the belief held by Lamson and/or his supporters that the second trial would understandably be a risky one. In the first trial, they had underestimated the prosecution and overemphasized the strength of their own case. In a county with a strong political gang and potentially suspicious goings-on, fighting strictly by the rules might get you executed. McKenzie was a street fighter as well as a lawyer, the equivalent of a William Kunstler or a Johnnie Cochran in our era.

Prosecutor Lindsay knew McKenzie's tenacity. Whenever McKenzie seemed to be gaining control of the courtroom, Lindsay would shout out objections to McKenzie's "police court tactics" or would refer to McKenzie as a "police attorney" from San Francisco. Certainly the judge, if not some of the jurors, would understand the reference to McKenzie's radical activities.

The defense again massively underestimated the prosecutors, who said they hadn't decided whether to call any new witnesses. They were, of course, busy gathering numerous new witnesses.

For Lamson and his family, the second trial meant a return to San Jose and an end, at least temporarily, to the threat of execution. Lamson's sisters took up their accustomed seats as jury selection began in February 1935. Also present in his usual seat near the prosecutor's table was Frank Thorpe, Allene's brother, who had not been shaken in his belief that Lamson was a murderer.

Unfortunately for jury selection, mid-February was spraying season in the Valley of Heart's Delight. Many of the orchardists were excused as their names were called from the panel of 150 veniremen, narrowing the available list. Three deputies under Sheriff Emig were immediately dismissed for cause. Although the Supreme Court differed on the legality of the presence of a sheriff's deputy on a jury, Judge Syer was taking no chances.

Clashes during jury selection between Lindsay and McKenzie, two fairly irrational and potentially violent individuals, proved to be the rule rather than the exception. McKenzie was confronted with a housewife from San Jose who denied that she had ever promised "to hang Dave Lamson high and dry" if she managed to serve on his jury. McKenzie asked an orchardist who did eventually become a juror if he knew Frederick Proescher, "who is a doctor and who claims to be a chemist." When the prosecutors objected, McKenzie agreed to rephrase his question. Did he know Frederick Proescher, "who is a doctor and who doesn't claim to be a

chemist?" After more noise from the prosecution, the judge sustained the objection to McKenzie's sarcasm.

Lamson's defense team was contentious, but their tactics may have backfired. Jury selection dragged into the eighth day, already a California record. Reporters for local newspapers were so bored that they counted the rate of gum chewing by E.T. Elles, one of the already passed jurors.

To many observers, a change of venue was a reasonable motion given the defense's attitude about the corruption in Santa Clara County. The number of potential jurors who turned out to be Sheriff Emig's deputies was a warning signal as well.

A Prosecution Witness Cuts His Own Throat

The appeal decision seemed to give the Lamson defense team the edge. Their expert witnesses would testify that Allene fell and hit her head on the edge of the sink and bled to death. They had faith that the issues of circumstantial evidence would turn in their favor. They believed they could cause the collapse of the prosecution's case when they showed that the so-called murder weapon, the pipe, had been in the backyard for years and in any case could not possibly have tested positive for human blood.

They were wrong in every instance. What was probably even worse is that they believed they couldn't lose.

At least one member of the defense team had learned his lesson from the second trial: Ed Rea. He wanted a change of venue for the second trial, but the new chief counsel, McKenzie, did not agree. McKenzie "was so sure of this case," Rea said later, that he didn't want a change of venue. "He thought he could even convince the district attorney with his case." The district attorney and his staff were again being taken too lightly.

The prosecution resumed its old tale. Lamson, having had at least one substantial ongoing love affair, was living a double life; Allene Lamson, for whatever reason, including the possibility that she knew about Lamson's affair, displayed a sanitary napkin to avoid having sex with her husband. When he discovered the trick, he killed her with a nine-inch pipe. He attempted to wash up the body, presumably to carry it off somewhere for disposal, although the prosecution turned vague at this point.

The prosecution avoided the extraordinary difficulties of this reconstruction, such as premeditation, needed for a first-degree murder conviction. Judge Syer helped them immensely in the first trial by defining premeditation as virtually an act of an instant. By most definitions, premeditation is "a design or intention, formed to commit a crime or do an act, before it is done." By legal tradition, some time—the precise limits unstated—must elapse between intention and deed. The context of the crime usually provides the time limits. (Today, "deliberate intent" sometimes substitutes for "premeditation.")

How Lamson intended to dispose of his wife's body was another difficult issue. The washing up of her body and/or the bathroom involved *concealment* but not *disposal*. If Allene was murdered, there could only be one murderer. But was there a *corpus delecti*; that is, was there a murder? No accident theory could be allowed.

Whether by skill or cunning, the prosecution uncovered new evidence and witnesses. They would build on their basic strategy of relying on expert testimony, using surprise witnesses and damaging Lamson's moral character.

The prosecution proceeded with two new witnesses. First of all, they used the surprise testimony of a local chauffer, "Big Nick" Vojdovich, who said he was driving across the Stanford campus on a country road near Lake Lagunita at about 2:30 or 3:00 a.m. on Memorial Day when he saw a man with a "blond, curly-haired" woman. The man, he said, was clearly Lamson. How did he know? He held up a *San Francisco Chronicle* page with Lamson's picture.

Next up was the Stanford University switchboard operator, Elsie Hall, whose feats of memory were equaled only by her tendency to eavesdrop. She recalled Lamson speaking from his university press office to a "Mrs. Kelly in San Francisco." He asked her when he was "going to see her." He said "he couldn't wait much longer and that he loved her very dearly." Hall quoted "Mrs. Kelly": "Please be careful—somebody in the office might hear you." Lamson said that "he didn't give a damn if the whole world" heard him. The defense foolishly delayed rebutting this damning testimony.

In the first trial, Lamson's maid, Delores Roberts, was pregnant and unmarried. The implication was that David Lamson was her lover. Now she appeared as Mrs. Delores Sorenson, a newlywed. She became a defense witness, stating that Lamson always treated her with courtesy.

The prosecution cut her off, reading a letter she had written to her future husband. Its most damaging part read:

Sunday was Mrs. L's birthday—one reason I had to get back here. Mr. L. had to leave suddenly and, of course, left Mrs. L. to enjoy herself alone. And were things popping around here! They have been off and on for some time.

If one of them doesn't give in pretty soon we'll find ourselves in Reno! It's gotten nearly to that, I think, but probably they are too sensible to get so far gone. After all they did love each other—which doesn't always mean much but should in this case and probably will.

Mrs. L. decamped just after Mr. L. left and was gone all day and came home without any explanation at all which bothers me a good deal—or did.

I still can't imagine where she could have gone or what she did. It is all together quite mysterious and I can't help wondering what it all means.

Certainly the jurors wondered. Such a letter must have carried immense weight with them. It spoke to disagreements, however vague, which nonetheless could lead to "Reno" and divorce. It spoke of a couple who were not paying much attention to each other and who had loved each other only in the past.

Still another blow to Lamson's reputation came from Sara Kelly, his supposed lover. Previously her testimony was unopposed, but now she was a defense witness. Announced as Mrs. Neil Simonds, courtroom voices spontaneously cried out: "Who?!" Sara Kelly was now married. She didn't write poems *to* or *about* Lamson. She never had the phone conversation reported by the switchboard operator. She was, as everyone could see, not a blond.

Lamson's and Kelly's "business" trips to a resort *were* times she received an occasional corsage from him, but never lingerie, actually a gift from her fiancée. She made a good impression on the jury. The *Palo Alto Times* observed that "several of the women jurors sat forward in their seats, smiling in accord with the frequent, quick smiles of the attractive young woman on the stand." The paper also noted, as it had not for any other witness, her outfit: a dark, navy blue skirt and jacket with a pink flowered waist-shirt. She later told reporters, "I was never in love with Dave Lamson, and I never would be."

The prosecution was at first unnerved. They asked Judge Syer if they could cross-examine her a week later. Syer refused, giving them overnight to review her testimony. It was one of the rare times he didn't give in to them.

A.P. Lindsay cross-examined her the next morning, asking about her love poems. Lamson "was a critic of poetry—I sent it to him not for publication

but for criticism," she replied. For this trial, the prosecution came up with still another poem by Kelly. The poem strengthened the chain of circumstantial evidence against Lamson even further, for this poem was about flowers:

> *I should like to bring you flowers…*
> *Spring flowers.*
> *I see a pear tree on a*
> *Distant hill.*
> *White and delicate against*
> *New live green.*
> *I shall pick that vision for you.*
> *These shall be your*
> *Spring flowers.*

The prosecution wanted to know if this was her flowery return for Lamson's gift of flowers. Sara Kelly denied this, but real and poetic flowers exchanged as love tokens had a telling effect.

Prosecutor Lindsay knew nothing about poetry or poetic technique. Sara Kelly said she often wrote poetry and even limericks for a contest she was preparing for her newspaper. Lindsay pursued her relentlessly. Didn't these limericks represent the same "spring flowers" Lamson gave her?

The courtroom with its Stanford University contingent tittered. Lindsay didn't know what a limerick was. Most poetry students knew the poems in evidence were not limericks. Most of the citizens of Santa Clara County did not. The gap between town and gown, country folk and sophisticates, opened a bit wider. Lindsay tried to recover. "You don't mean anything when you write poetry? It means nothing that you just received a box of spring flowers?" he asked, trying to regain his edge in the courtroom.

"Positively not," said the poet and ex-student at the edge of an age when poetry should "just be, not mean," a formula that may have been the goal of academic New Criticism. But it was a setback for Lamson.

The prosecution returned with Dr. Meyer, who repeated his shocking testimony from the first trial. Allene Lamson, he said categorically, had been struck by four blows as her hair was being pulled by her murderer. She could not have received her wound from falling and gashing her head on the sink.

Next up was a curious professional witness, Dr. Clement Arnold. Formerly a clinical instructor of medicine at Stanford, his "hobby" was "murder evidence," according to *Time* magazine. He confirmed the earlier experts' testimony for the prosecution about the unlikelihood of any distant

arterial spurts. Called back to the stand a week later, he reported a bizarre experiment on arterial spurts he had carried out on himself, setting a new record as a surprising witness,

Arnold testified that one of his own occipital (neck) arteries was cut. "So far as I know," he said in court, "no one has ever experimented with a human being to find out how far his blood will shoot." The thick bandage on his neck indicated that the doctor was his own guinea pig.

He described his experiment in detail. After a barber shaved his neck, he went to the office of a surgeon with a photographer present. "I had eaten," he said, "a large meal, and drank two or three cups of coffee and smoked many cigarettes to raise my blood pressure." He then located the occipital artery by himself. The surgeon made a horizontal incision about one and a half inches long and clamped the artery. The clamped artery was then held out from the tissue to facilitate spurting.

Dr. Arnold spurted. But he only spurted six inches "vertically" and twelve inches "laterally." "This proves," he said, "that a severed occipital artery cannot throw blood around a bathroom as the Lamson defense contends." Photographs of Dr. Arnold's wound were then entered into evidence but were marked "for identification purposes only" because the defense had objected to them as "irrelevant, incompetent and immaterial."

Dr. Arnold's feelings were hurt. His interest in photography waned as he left the courtroom. He smashed the flashbulb of a photographer who dared to take a picture of the doctor from behind. He had agreed, he said in a great temper, to be photographed from the front only. Arnold's choice of angle would have given the press no view of the bandage at all. In the end, the photos published showed a side view: a pudgy face, topped by a monk's tonsure, with a massive bandage behind the left ear—not the doctor's best side, apparently.

The local press agreed with the defense's refusal to cross-examine this hostile witness. After all, a man who would have his neck cut would hardly be a disinterested witness. But the defense went wrong again. Arnold's experiment hardly matched the conditions of Allene's own wounds. Why not have the doctor rant and rave on the stand when pushed during cross-examination? His testimony would therefore be suspect in the eyes (and ears) of the jury.

It would have been amusing and important to know what the Sherlock Holmes of Berkeley, taking the stand, would have made of Arnold with his left hand while he demonstrated the absurdity of the prosecution's tests on the pipe that mistook *blood* for *organic material* with his right.

The wall of the Lamson bathroom at 622 Salvatierra Street, with a protractor and string marking blood spurts from the single-impact blow to Allene Lamson. Exhibit facilitated by E.O. Heinrich in 1934. *Courtesy Special Collections, Stanford University.*

Proescher, after all, was testing, not cutting, *grass*, while Arnold was cutting his own throat.

Confronted by three-foot-square enlargements of photographs taken of spots near the service (back) porch and near the doorknob of the kitchen door, Heinrich was dismissive. He had examined those spots and they were varnish, not blood, as the prosecution had contended.

Heinrich then changed from chemist to physicist. He used enlarged photographs of his own charts and stereopticon slides to propose a pattern of bloodstains in the bathroom consistent with the belief that Allene Lamson fell and hit her head on the bathroom sink. With confidence, Heinrich located the impact point at the corner of the bathroom sink as "two inches below the rim." Only with that point as the source of impact could the pattern of bloodstains result.

McKenzie pressed Heinrich. Could she have been hit on the head by a person? "No, sir," Heinrich replied. "Every spot I could possibly locate belonged to one single pattern and all comes from this single point."

Heinrich then turned to actual tests he did in the Lamson bathroom with a live model, Christine Phelps, one of his assistants in his crime lab. Heinrich demonstrated that not only must Allene have hit her head but that blood spurts from a ruptured artery traveled forty-four to fifty inches from the wash basin to various surfaces in the bathroom.

Having successfully blocked Heinrich before, Lindsay now tried a clever maneuver. He wanted to see the demonstration of the fall again, but this time it was to be done in the courtroom, right before their eyes, and with a model—he was being vicious here—closer to Allene's body size and therefore not Heinrich's assistant, always described by reporters as "attractive."

This was a clever but risky maneuver. If the demonstration was held and it failed, the defense would be in deep trouble. If it succeeded, the prosecution might be in a much weaker position with Heinrich's testimony than they were now, convincing as it was.

McKenzie huffed and puffed. The prosecution is not permitted to demand that the defense stage a demonstration. But was this a trap? Refusing to permit a new demonstration might make the defense seem unconvinced of its own case.

McKenzie slyly offered to hold the demo in the Lamson bathroom. Lindsay was outraged: "That's impossible. You cannot get all twelve jurors and the two alternates in that room." Lindsay said he could have a mock-up up by ten o'clock the next morning. His carpenters, of course, had already been at work.

The judge was not above slyness himself. When McKenzie objected to Lindsay's request as "judicial misconduct," the judge told the jury not to pay any attention to Lindsay. But Lindsay's trap was sprung. The defense agreed to use the prosecution's model bathroom in the courtroom for Heinrich's demonstration. The only compromise McKenzie eventually secured was a poll of the jurors to see if they wished to see the real bathroom regardless of any demonstration.

The next day, the "comely" Mrs. Phelps tried to hit her head on the model sink twice. The first time she fell completely out of the tub; the second time she hit her head and her body ended up as Heinrich predicted it would. Phelps did not fall, however, free-style: she was "held" through her fall by Heinrich. The jurors were all perched at the mock-up's openings: an imitation door and window.

When Lamson was finally called to testify, his denials were emphatic. McKenzie asked him if he killed Allene or ever "lay a hand violently upon your wife." Lamson fairly shouted, "Never—never in any way!"

Lamson said that he *once* believed his wife had been murdered. The prosecution had, in this trial and earlier, asserted his utterance—"My God, my wife has been murdered!"—as a bizarre admission of guilt; only he (the murderer) would know she had been murdered.

But the jury may have thought Lamson was hiding something. It is hard to say. Certainly Lindsay wanted to make him seem neglectful and generally suspicious. Lamson didn't call for a doctor. Lindsay denied that he took his wife out of the bathtub. How could he possibly know his wife was dead? How long did he stay in the bathroom before going to the front door to Mrs. Raas and Mrs. Place? Lindsay pushed on. "You don't remember things that morning very clearly, Mr. Lamson?" Lamson's reply was eloquent but perhaps too literary for this jury:

> *It was like being under water with waves coming over you. You come up between the waves. It was as if a series of pictures were taken with a camera. Those flashes—most of them—were quite distinct. In between the flashes things didn't exist—it was quite foggy. I remember the cold cloth on my face. I remember Fred Frehe* [Palo Alto policeman] *coming in very clearly. But there isn't any continuity to it at all.*

Fitzgerald began his closing arguments in a courtroom overflowing with more spectators than ever before. Long lines of disappointed spectators stretched outside. He told the jury that Lamson murdered his wife because

of a fatal combination of marital discord at home and extramarital relationships on the road. The case was therefore a simple one.

Fitzgerald returned again to "washed blood." Since Allene's body was clean in a bloodstained bathroom, "that could mean only one thing," Fitzgerald shouted. "That body was washed." Why? "There is only one reason for washing the body. That is to prepare a way to dispose of it."

When it was his turn to speak, McKenzie quickly lived up to his reputation as a radical and flamboyant speaker. The orchardists of the Valley of Heart's Delight heard him move from Goethe to Jesus in his first few sentences. It's doubtful that any of them had even heard of the German writer, whom McKenzie quoted as an expert on the subject of the "tribunal of one's conscience." From Jesus he established the need for mercy.

In front of the jury he placed a four-foot-high poster with the contradictory statements made by Proescher in dark letters. "I say he changed his story twelve times," McKenzie asserted. "I say, in a kindly way, that is a wretched memory." He has been a "careless witness," exceeding any other witness's contradictions in McKenzie's twenty-two years of trial experience. "If Dr. Proescher isn't impeached by his own testimony, then no witness was ever impeached in a court of justice."

His next target was Meyer's analysis of the wound. Allene Lamson had a "ring fracture" on her skull, the kind of wound only found as a result of a fall. Furthermore, six thousand accidental deaths occur in American bathrooms every year: "The death of any one of these persons could be subjected to exactly this type of investigation."

All chemical tests have gone in Lamson's favor. Red crayon used by a child and red varnish used by Lamson to stain his daughter's toy chest were the sources of any distant red spots at 622 Salvatierra, not Allene's blood. The simplest explanation for bloodstains outside the bathroom is that "there were at least fifty people" in Lamson's house that day. "This is innocent blood. How it got there we do not know." Dr. Proescher at one point had to admit on the stand that from the first to the second trial he had confused which door had a bloodstain.

As a bonus, staining his daughter's toy chest demonstrated that Lamson was preeminently a family man not given to wandering the Stanford woods with girlfriends. All of Lamson's activities on the fatal day supported McKenzie's cozy portrait of Lamson and his wife. Lamson slept apart from his wife the night before her death because she had indigestion; for the same reason, he prepared a late-night meal for her. "No man ever thought to invent a story that he gave his wife soup and a sandwich at four o'clock in the morning."

McKenzie then lectured the jury with a giant poster quoting the standard *Treatise on the Law of Evidence in Criminal Issues* (1912): "Circumstances, trivial in themselves, take on an exaggerated character the moment suspicion is directed toward a person accused of a crime."

Anticipating Lindsay's return to the Dickensian theatrics of the first trial, McKenzie insisted that "no banging on the rail of the jury with a pipe will change" the innocent dailiness of the Lamsons into guilty evidence. "You don't live decently all your life and treat another person with kindness and then change all at once." Lamson is on trial for his life because some people have seen "some evil thing" in "an ordinary act of courtesy."

McKenzie concluded: "Society has charged David Lamson with being a leper; that in the interests of society he must be destroyed." The jury members must ask themselves if they are "convinced to a moral certainty and beyond any reasonable doubt" that Lamson is guilty.

Then Lindsay launched a hysterical attack on all the major defense witnesses, not only impeaching their testimony—a reasonable enough tack—but asserting that they, collectively, individually and consciously, violated the law.

From the prosecution's angle, Lamson's premeditated murder went like this: he struck his wife four blows on the head when he saw that she had tricked him into sleeping apart from him, lying about her period. Blood from his swinging arm hit the trapdoor in the hallway ceiling outside the bathroom door. He dragged her into the bathroom, where he began to wash her body as prep for disposal. Just then or perhaps a bit earlier he discarded all of his bloodstained clothes and went outside to turn on the sprinkler. Having seen this gardening activity, Place and Raas knocked on the front door; Lamson appeared and began the performance of his life.

Lamson's "great mistakes," Lindsay stated, actually "pale into insignificance when you realize that he killed his wife." In short, think of the bloody body and forget my reconstruction: "Two went into that bathroom and the stronger came out alive." Now she was hit *inside* the bathroom, a reconstruction that would make bloodstains splashing on the hallway ceiling very unlikely. Although at this moment it sounded as if Lindsay was saying that Lamson killed his wife *in* the bathroom, it really didn't matter.

Why not? Because details never mattered to Lindsay; excitement and the stimulation of a jury did. Having accused two prominent local women—Lamson's sister and a distinguished faculty wife—of sabotaging evidence, he then turned to a wholesale condemnation of virtually everyone else associated with the defense, charging unimpeachable witnesses with perjury.

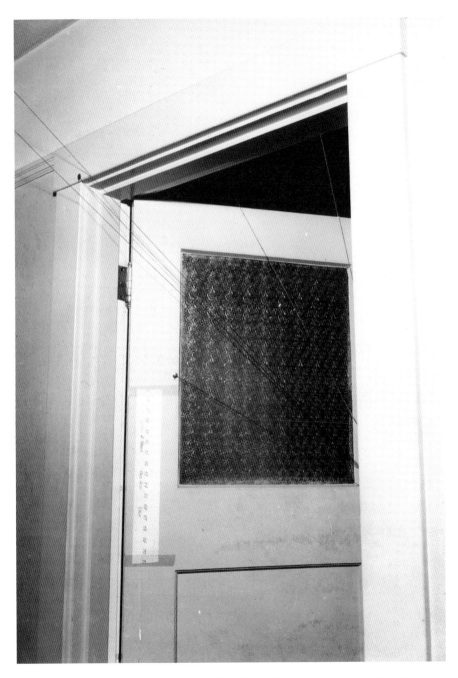

The door of the Lamson bathroom at 622 Salvatierra Street, with string marking blood spurts from the single-impact blow to Allene Lamson. Exhibit facilitated by E.O. Heinrich in 1934. *Courtesy Special Collections, Stanford University.*

Lindsay's next two targets were Heinrich and George Weber, Palo Alto criminologist. He charged that a line of blood spots on the outer side of the door leading up toward the two notorious spots on the ceiling trapdoor had deliberately been placed there after Lamson had been arrested. Lindsay was beside himself: "Those spots are going diagonally upward across the glass. The defense wanted to account for those spots on the trap door."

Lindsay's photograph, taken on June 14, 1933, shows no spots. Weber's photos, taken eleven days before, showed spots on the edge of the door and on the lintel in a line from inside the bathroom leading to the spots on the ceiling. How could this be?

The spots, Lindsay said, "weren't there up to the time we took our photograph June 14. If that's what they've got to do to win their case I don't want any of it." Who was the culprit?

"I am charging Heinrich with deliberate perjury in this case," Lindsay announced. McKenzie jumped up: "Well, you are hiring him," meaning that Heinrich in the past had testified for the prosecution in virtually every previous case.

"We're not using him anymore. We're through with Heinrich," was Lindsay's extraordinary reply: he had just charged the Sherlock Holmes of Berkeley—a key prosecution witness in hundreds of cases—with perjury in open court. Lindsay wanted to convict Lamson badly, but part of his anger was clearly directed against the criminologist who had defected, albeit only temporarily, from the ranks of the accusers to those of the accused.

Altogether McKenzie cried "prejudicial misconduct" in Lindsay's face seven times. The judge caught the defense by surprise because he satisified every one of McKenzie's assignments of prejudicial misconduct by telling the jury to disregard the prosecution's remarks on the points Lindsay had made.

Certainly Lamson's defense team should have been in an excellent position at this point, *if* the jury could ignore so many dramatic accusations by Lindsay. But from the point of view of the jury, something bizarre was going on: McKenzie, according to the *Palo Alto Times*, had been reading a magazine during the first day and a half of Lindsay's closing argument. He was sitting in full view of judge and jury. What were they to make of this incredible discourtesy? Some courtroom observers speculated that McKenzie came alive only at the points in Lindsay's argument where McKenzie believed he made legal history.

Lindsay's wrap-up was anticlimactic. He stopped his argument briefly to confer with the other members of the prosecution team. He then announced, "Well, we'll put it this way—we ask for the extreme penalty."

Judge Syer began to read his instructions to the jury. Encouraging to the defense was his addition of manslaughter (with a penalty of from one to ten years) to the list he had given to the first Lamson jury. Those jurors were limited to first-degree murder, with or without a recommendation for leniency; second-degree murder; and acquittal. The manslaughter charge could allow, for example, this new set of jurors to accept Allene's death as an accidental result of a violent struggle or fight in which Lamson had no intention of killing his wife. This last possibility, however, was never put forward by either side during the trial.

After the court session was over that day, reporters asked Lindsay if he planned to prosecute Heinrich and Weber on charges of perjury: "I have nothing to say."

Rumors soon circulated that the jury was already casting split ballots, with a slight majority for conviction. In this case, rumor was right; on the third day of their deliberations, the foreman told the judge, they were already deadlocked at 9–3. The judge told the foreman, Mary Richter, not to reveal what the majority vote stood for. The *Palo Alto Times* reported their "air of utter resignation" when the judge sent them back to reconsider their verdict.

Lamson told an Associated Press reporter that he didn't think dismissal was likely. He was resigned to face still another trial, given the "vindictiveness" with which Lindsay had already prosecuted the case. It was a prophetic remark.

Professional expert witness Clement Arnold, while the jury was still deliberating, presented his bill for his services: $645 (or about $11,000 today). He had cut his throat for the prosecution, and he needed to be reimbursed.

The Lamson jury returned to Syer's courtroom the next day to report that no progress had been made. "There has been no change in the ballots?" Syer asked the foreman. Mary Richter replied that there had been "changes" but that they had been "hopelessly deadlocked since Saturday." "Do you think," the judge pressed, "that there is a reasonable probability of reaching a verdict?"

Richter was resolute: "I think it is going to be impossible to change." The judge asked the jury "to deliberate once more" in the afternoon, stressing the word "once." The jury was clearly going to be hung, but Syer wanted to be sure. McKenzie objected to sending the jury back to reconsider: "All world records, all California records in keeping a jury out have now been exceeded, to the best of my knowledge." But the jury retired once more.

When the jury returned four hours later, the result was obvious: they were still deadlocked at 9–3. The judge polled the jury on the question of the

possibility of a verdict. Frank Elles, the gum-chewer who—it would soon be learned—voted for acquittal, said, "There's not a chance in the world, your honor." Other jurors echoed Elles's remark.

After the poll, Judge Syer announced: "The court is fully convinced and is now of the opinion that there is no reasonable probability of your coming to a verdict. And for that reason you are discharged from further service in this case." He told the prosecution that they had two days to request a date for a new trial, to dismiss the charges against Lamson or to ask for a continuance. He turned once more to the jury and told them: "I regret very much that it is impossible for you to agree. But I am convinced you have done your duty."

The second trial of David Lamson was over. Lamson, however, remained in jail.

News of the jury's detailed deliberations leaked quickly to the press. The jury, it was reported, was actually at 11–1 for conviction for manslaughter at one point and then settled regularly into the final 9–3 vote for second-degree murder. Although Lamson could of course not know it, he was this time at least not in danger of execution. The manslaughter vote may have been a compromise maneuver, winning two acquittal types over to the less severe charge. About thirty ballots were taken; Frank Elles, unofficial historian of the group, said that he had a complete record of the ballots but that he wouldn't say anything "unless somebody lets the cat out of the bag."

In any case, one juror said that he was for acquittal from the very beginning: "I remained firm in my belief that if Lamson was guilty he should be hanged, and if not should be acquitted." He said that the "state's case never convinced" him of Lamson's guilt. "Common sense told me that you couldn't hit a woman over the head with a pipe and get a square depression."

Lamson was interviewed before he was returned to his cell:

Naturally I feel disappointed at the failure of the jury to acquit me. I fully expected vindication. I am still confident I will receive vindication and thorough exoneration. For my friends who have stood by me I express my gratitude.

Crowds of people filled the hallways of the courthouse and the alley between the courthouse and the jail. Lamson and McKenzie were permitted to talk to the press.

Lamson commented on his tendency not to show much emotion in court: "I don't like to see people cry in public. People have asked me about the calm I have always displayed. There's an easy and quick explanation for it. It's easier to keep going than not to. I think that once you get going, I

mean emotionally going, you keep on, and on." He praised his sisters and McKenzie: "My sisters are the most remarkable people in the world. They have character, courage—everything that matters. They are in a class with Ed McKenzie. I never believed there would be anyone like them."

Meanwhile, the prosecution team called on the jurors to help them decide whether to move forward to a third trial. Despite local complaints that an inordinate amount of money had been spent on Lamson's prosecution to date (pro-Lamson forces said it was at least $60,000), District Attorney Thomas ruled out cost as a deciding factor.

The next morning, Lindsay, with a fair amount of enthusiasm, told Judge Syer that "it's our pleasure that the case be set for retrial. It should and will be retried." McKenzie was absent, working on an oil case in Los Angeles. Rea asked that the date for the trial be delayed until McKenzie would be available, and the judge agreed.

Back in his cell, Lamson repeated his expectation of vindication: "There is a superstition about the third time being a charm. But aside from that, the law of averages will not allow jurors to refuse to face the facts and acquit me."

Lindsay in his press conference played on the town-gown issue that was always below the surface in this case and emphasized that no one would have complained about the costs of a retrial "if it were a defendant with less of a social background and of less influence." Apparently some of the muscle of the local Lamson Defense Committee was making itself felt.

Lindsay even alluded to the charges of local corruption in Santa Clara County: "Not to retry Lamson would be just another link in our already badly demoralised system of handling crime." Without a trace of irony, he noted that there was a danger of Santa Clara County being known "as a fine place to commit crime."

A new trial would be held within a month. McKenzie would be replaced by Leo Friedman. And Lamson's San Quentin memoir, *We Who Are About to Die*, was published after being serialized in a San Francisco newspaper. Lamson's advocate, Yvor Winters, had served as "agent" for the book, convincing Maxwell Geismer, the leading New York City publisher of Scribner's, to acquire the memoir. Winters explained how important the book and his, Winters's, introduction to the book would be in securing Lamson's eventual release and exoneration. Like the Lamson Defense pamphlet (Winters confidentially admitted to being its sole author), his introduction, later converted to a possible appendix, was a master work of concision and argument. Geismer did not, for reasons that seemed to have to do with possible libel, publish Winters's essay with the memoir.

More postponements marked Lamson's continued imprisonment in the fall. Judge Syer denied a petition for change of venue, saying that a fair trial in Santa Clara County was possible:

> *There has been no proof offered that the people of this county have shown sufficient antagonism to threaten violence. When the entire equilibrium of a community is upset a change might be warranted. Such, however, has not been the case in this county, where only a comparative few have come in and sworn to prejudice.*

Despite Syer's confidence, he was soon besieged by petitions from the Lamson Defense Committee and briefs filed by Lamson's lawyers. In a nineteen-page reply to defense allegations that he was either biased or prejudiced against Lamson, Syer announced that he was disqualifying himself from the case. He said that he did not wish to try anyone who would not expect him to secure a fair trial. This was certainly a big boost for the Lamson forces.

A new judge, J.J. Trabucco of Mariposa County, was appointed. The *Palo Alto Times* printed two photos after Lamson's second trial that conveyed his ongoing ordeal. In the first, in May, he rests his left hand on a set of prison bars as he stares out to the street. Six months later, he is still in jail, and in the second photograph, he is shown building a dollhouse for his daughter, now four years old.

A so-called third trial of Lamson was actually a mistrial. When Trabucco convened the court in November, the county clerk announced that 2 of the 626 names on the jury list could not be found. Lamson's defense moved for a mistrial, and their motion was granted. A new trial was announced for early 1936. Lamson was, however, returned to his cell.

Soon afterward, the Lamson Defense Committee received unexpected and significant support from Alexander Woollcott, the flamboyant and influential writer and radio personality who was one of the leaders of New York City's elite literary circle the Alquonquin Club. Woollcott loved controversy. And he was willing to take a stand. When one of his radio sponsors, Cream of Wheat, asked him to ease up on "caustic references to people like Hitler and Mussolini" because his remarks might be offensive to Americans of German or Italian backgrounds, he said that he would accept no political censorship.

His program, *The Town Crier*, he suggested, would therefore go off the air, as it was unlikely to attract another sponsor. Woollcott did eventually give up his program and an estimated income from it of $80,000 a year.

Lamson in the back seat of an auto between two deputies. Date unknown. *Courtesy History San Jose.*

Before he went off the air, however, he had broadcast Lamson's story to a national audience. Woollcott had read *We Who Are About to Die* and began to correspond with Lamson: "All I want to be sure of is that no glib broadcast or platform utterance of mine should, for all good intentions, do you more harm than good."

On a California lecture tour, he visited Lamson and donated the profits from several of his lectures to the defense committee. He agitated among friends and writers for Lamson: "I am off to dinner with Dashiell Hammett, who shares my ideas, if not my feelings about the Lamson case." When a reporter for the *San Jose Mercury Herald* warned him that supporting Lamson might offend people in the area, he replied: "That's jake with me. There are people in every community whom it is not only a duty to offend but a positive pleasure."

Woollcott's biggest boost for Lamson came in terms of radio publicity for Lamson's book. Woollcott's biographer reported that sales on both coasts jumped after Woollcott reviewed the book over the air. Even bookstores that had shied away from the controversial case began to stock the volume. Within a week, the first printing of five thousand copies was gone.

Lamson wrote Woollcott with enthusiasm:

> *You in fifteen minutes did what we failed to do in two and a half years—throw the weight of public opinion completely. Those who had been neutral or unconvinced are now definitely friends; the band of loyal friends are exultant and triumphant and rearmed; what the enemies think no one knows, for they have no word to say. The care with which you thought out what you had to say has disarmed them; criticism is impossible, for you anticipated and met it at every point. There is not the least whisper of an ulterior motive...your reputation, together with the manner and matter of your utterance, is far beyond that. So far as the case is concerned, the effect you have had is monumental and good.*

10.

"HANGMAN" BUFFINGTON TRACKS
BLOOD IN THE LAMSON HOME

The selection of a third Lamson jury began in January 1936, when California was again suffering under the threat of widespread lynchings. The year before, a mob had broken into the Yreka city jail at the Oregon border and carried off a man who had confessed to killing the local chief of police.

In Fresno, a parolee, Elton Stone, confessed to the murder of the fourteen-year-old daughter of a prominent attorney and Stanford University graduate. She was shot while reading behind a closed window. Stone implied that he wanted to "get" one of the family: "When [her father] hears my name, he will know why I did it." Later, Stone changed his story, suggesting that he had no real reason for killing the girl. Fearing a lynching, the police rushed Stone to Folsom Prison for safekeeping.

His trial at Fresno took place just four days later, with an angry lynch mob outside the courtroom. Stone immediately pled guilty and asked for his sentence. The judge sentenced him to die, but he had to escape a lynch mob crying out, "Let's take Stone!" Only the presence of a large force of California Highway Patrolmen enabled Stone to return to prison, where he was hanged officially a few weeks later. He never explained why his crime was based on a grudge against the victim's family.

When Lamson reached the San Jose courtroom for his third trial, none of the early rowdiness of eager spectators was apparent and certainly no lynch mob gathered. The new judge, Trabucco, came from the Yosemite Valley, two hundred miles to the east of San Jose.

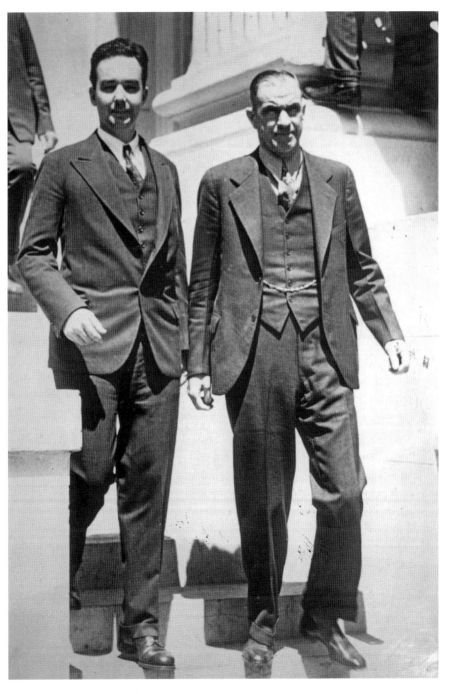

Lamson with Leo R. Friedman, his lead attorney for his third trial, 1936. *Courtesy History San Jose.*

Lamson's optimism had returned. Interviewed briefly before the trial began, he asserted that he had "won a victory" in his second trial and that he was confident that he would be cleared this time around. The irrepressible McKenzie had been replaced by the more scholarly and sober Leo R. Friedman, who joined Rankin and Rea. The prosecution team Lamson faced was familiar: Lindsay as usual was the leading force, with Thomas, Fitzgerald and Bridges.

Many potential jurors virtually dismissed themselves by agreeing that they had fixed opinions about the case, but the *Palo Alto Times* said it was their fear of being locked up for the duration of the trial. A disinterested observer may have indeed wondered if a fair trial in Santa Clara was possible.

The prosecution's strategy remained unchanged. The life-sized photograph of the bloodstained corpse of Mrs. Lamson would again be hung in front of the jury. The dramatic wooden model of the bathroom constructed for the second trial would be back. Despite some successes in softening their impact, Drs. Proescher and Meyer would be back. And the prosecution's habit of springing surprise witnesses into the arena would also continue.

The atmosphere of this trial was different, the *Palo Alto Times* reporters noted. Lamson himself appeared "jocular, unworried, at ease." The judge was "genial and informal," defusing the "critical tension" so characteristic of the earlier trials.

Friedman pursued his advantage by disarming a number of additional prosecution witnesses. Palo Alto undertaker Frank A. Hopgood admitted that the parade of police officers through the Lamson home had disrupted the crime scene before any photographs were taken. "Hangman" Buffington, Hopgood testified, had not noticed that he was tracking Allene's blood throughout the house.

Chief of Police Howard Zink admitted that he could not recall whether one or both of Allene's slippers were found in the bathroom. The earlier trials had made much of Lamson tracking blood in the hallway outside the bathroom; it was obvious that any assertions based on bloody footprints were less than worthless.

Undersheriff Earl Hamilton testified that the bag of evidence had indeed mixed together Allene's slippers and bedclothes as well as the towels and bloodstained bathmat. Deputy Sheriff Moore had testified at the earlier trials that the slippers and various other pieces of evidence such as bloodstained clothing had been carefully wrapped in paper to keep them separate. Imagine his surprise when Friedman thrust in front of him a photograph taken on the

night of Allene's death that clearly indicated crucial pieces of evidence lined up and unwrapped. Was he lying? Or was he just *sure* he had done it right?

Encouraged by his somewhat easy victories over most of these witnesses, Friedman began to expose Lindsay's reliance on blood. "I believe," Friedman objected at one point, "this is being done with the deliberate intention of satiating the jury with all this blood." Bloodstain expert Proescher had to admit that only one "pin point" out of three hundred particles tested for blood.

Friedman sensed it was time to contest the prosecution's cavalier use of the pipe in the two earlier trials. He moved that the pipe on display be removed, as it had never officially been admitted into evidence and had never been offered as the actual murder weapon. Unfortunately, the prosecution then moved to enter it as such. This was a startling maneuver. No longer was the pipe a theatrical prop.

Friedman then brought into court a model of a skull to demonstrate a wound caused by an object that passed with a "sliding motion" across Allene's head and not by multiple impacts from a weapon. As if trapped by the prosecution's graphic obsessions, Friedman showed images of Allene's own skull from five different angles.

A second autopsy surgeon, Dr. Blake Wilbur, the son of Stanford's president, Ray Lyman Wilbur, testified that had Allene been hit repeatedly after being knocked down, she would have had facial bruises. The jury could see from the photos that she had none. Wilbur testified that a pipe or a "single application of force" could have created the wounds he saw, but it was not likely that a fall from a person's own height could result in such a "single application." Janet Lewis felt that this "wrong diagnosis" was especially damning.

There was one medical witness, however, whom Friedman could not budge: Arthur Meyer of Stanford's medical school. He was as self-confident as ever, even arrogant. He said with some vehemence, in the type of statement characteristic of the prosecution's approach to indelicate subjects: "I know to the best of my knowledge of no case of a person bleeding to death even when the scalp was torn entirely from the head." Of course, this bit of western frontier lore supported, at least metaphorically, the prosecution's central point: Allene Lamson could not have bled to death by herself.

The prosecution's case then shifted to an exposé of Lamson's bad character. Witness after witness linked Lamson to Sara Kelly. These witnesses, Friedman countered, would "guess a man to the gallows," but he managed, finally, to get the "love" poems excluded from the evidence.

As the trial proceded, Rea was overly complacent: "No one has put the pipe in Lamson's hand, no one has put blood on the pipe, and no one has put Lamson anywhere but the backyard when his wife met death. There is no case." Clearly he was ignoring what Winters had warned about the depth of the prosecution's cunning and dirty tricks.

The defense did get some breaks. Sara Kelly was not recalled by the prosecution, and Elsie Hall was not allowed to quote her remarks eavesdropping at her switchboard.

Friedman tried to waylay the prosecution's contradictory motive that Lamson killed his wife because she would not have sex with him. Instead, the prosecution promoted the remarkable notion that he killed his wife so he could continue having sex with someone he was already having sex with!

From two witnesses who could not appear in court, Friedman made two significant points. The first deposition, already submitted to the California Supreme Court, was from George Harrison, former resident of 622 Salvatierra, who stated that the pipe found as debris in Lamson's bonfire was actually his, discarded long before Allene's death. Furthermore, his sister had fallen in the bathroom and hit her head on the sink. She had survived the injury, however. She was lucky not to have joined the numerous others nationally who had fatal accidents "connected with baths," as a British commentator, Richard S. Lambert, had argued. *Popular Science Monthly* in 1931 had noted that "falls, of course, are responsible for most bathing injuries."

The second deposition was a valiant attempt to turn the suspicion of adultery away from Lamson. Paul Lehman wrote from Mexico City that it was he who had purchased lingerie for Sara Kelly in a Sacramento store in 1933. After opening with these impressive rebuttals to the prosecution's case, Friedman turned to two very different kinds of witnesses: a character witness—Lamson's sister Dr. Margaret Lamson—and a new expert in head wounds, Dr. A.A. Barger.

Lamson's sister, as in the earlier trials, brought out the worst in the prosecution. She enjoyed a high standing in the community, and it would therefore be even more important to impeach her testimony. Perhaps there was more than a hint of lesbian baiting at work: she was unmarried and had a long-standing relationship with another doctor, Margery Bailey, with whom she lived.

Instead of calling the Sherlock Holmes of Berkeley, as expected, the defense used a surprise witness of its own. San Francisco autopsy surgeon A.A. Barger testified that his experience of over ten thousand autopsies, fifteen

hundred of which involved skull injuries, made him confident to state that Allene died from a fall and not by a blow from a pipe. Furthermore, in every instance in which a skull injury had occurred, bleeding like Allene's under the scalp was inevitable. Arterial blood, he asserted, could spurt five feet.

The very next day, Friedman called Lamson to the stand: "The state contends…that you murdered your wife." Lamson's head tilted down as he replied, "That is not true—that is utterly false." He denied ever saying, "Why did I ever marry her?" He could not remember his movements after discovering her body.

Lindsay's cross-examination was brief: "Mr. Lamson, you have had considerable experience in amateur dramatics, haven't you?" Lamson's answer came quietly: "Not considerable. I was in a few plays at college, and had some minor parts in a few afterward." Lindsay, perhaps having seen too many Hollywood films, said: "That is all."

After Lindsay's dismissal of Lamson, Friedman continued to call more character witnesses to establish the couple's loving relationship. Dr. Bailey told the court that they were an "idyllic" couple. Another witness testified that she saw the couple two days before Allene's death: David was helping her across the street, and "they were eating a bag of popcorn," she reported.

The low point for the prosecution was calling a meteorologist, who testified that .63 of an inch of rain fell at Stanford in May 1933. Lindsay's extraordinary point was that Lamson would never have intended to burn leaves and grass in his backyard fire because everything would be too wet to burn in May. He built that fire only to dispose of the incriminating metal pipe!

If the matter were not so serious, the court, especially the jurors, should have laughed Lindsay out of the room. A number of the jurors owned or worked in Santa Clara County orchards all their lives; a little more than half an inch of rain in an entire month was minuscule and would have dried up in a day, much less in a month. This was, after all, the Valley of Heart's Delight, where dried fruit was an industry and a science.

The judge requested the attorneys' closing statements, expressing his desire for them to be "as brief as possible." No longer would a Clarence Darrow be allowed to sway a judge or jury with a twelve-hour speech, as was done in the Leopold-Loeb case in the 1920s. Lindsay was clearly conflicted. He feared Trabucco would rein in his histrionics. No pipe-banging on the jury box this time, therefore. If anything, he came across as a bit desperate and even more acutely devoid of logic for a man used to winning by any means necessary.

He did wave the bloodstained bathmat and towel found near or under (never clearly established which) Allene's body. He was clearly working up to his favorite subject—blood—when he was interrupted by two of the jurors who asked extremely direct and embarrassing questions about the location of stains on the bathmat. This precedent-shattering moment no doubt unnerved Lindsay, for he began to argue with the two jurors.

Lindsay then turned to an amazing indicator of guilt—the "callousness" of Lamson's behavior because he abandoned Allene's nude body "throughout the forenoon" of her last day: "He left her in the slaughterhouse of a room. He called no doctor to make sure she was dead. There she lay throughout the forenoon. Wouldn't any man that loved his wife ask that she be lifted out of that tub?" Lamson of course had tried to do just that, and—if he had succeeded—would have been even more vulnerable to criticism for moving the body. Lindsay held up the pipe he maintained was the murder weapon. Appealing to the rural roots of the jurors, he said, "I know that with this pipe I could kill a mule, a horse, or a cow."

Friedman, in his turn, responded to Lindsay's attempt to shock the jury by calling Lamson callous in not moving the naked body of his wife. Friedman was dismissive: "Suppose he'd have taken the body out and laid it on the bed? The state would have charged that he was attempting to conceal what went on in the bathroom. In other words he's guilty if he did and guilty if he didn't."

Friedman's final plea was emotional: "He has been sent once to San Quentin. He has waited there for the hangman's trap to fall. He has come back for a third trial. Time after time after time he has sat there and listened to this evidence as the state attempts to make his half-orphaned child a whole orphan." He then whispered his last words: "Let him go home. Let him raise his child!"

The next day was Lamson's final day in court. The courtroom was crowded, with more reporters present than ever before. The *Palo Alto Times* described Lamson as "grim" and "twitchy," reacting to any sound around him as he "sat like a statue, his knuckles white as he gripped the arms of his chair." His two sisters, Dr. Margaret Lamson and Mrs. Thoits, sat with professor Winters on the defense's side of the courtroom. Allene's brother Frank Thorpe was at his usual place on the prosecution's side.

Lindsay summarized his case once more, asking for the death penalty. He appealed to the jury to "remember the forgotten woman—Allene Lamson." Calling attention to Friedman's plea that the jury allow Lamson to return home to his daughter, Lindsay said sarcastically: "'Let him go home'? Is that the principle of justice by which we are governed?"

For the jury, the judge laid out the same possible verdicts as in the second trial: first-degree murder with the death penalty or life imprisonment, second-degree murder, manslaughter and not guilty.

J.J. Trabucco then did something odd. He gave the jury no directions about the direct evidence, especially the blood and the pipe, tilting the jury away from the prosecution. His remarks on circumstantial evidence were revealing: "Each link in the chain of circumstantial evidence must be established to a moral certainty and beyond a reasonable doubt." If these links, he added, "are not so established you must find the defendant not guilty."

Trabucco's final remarks indicated that he was aware of previous problems with the juries: "Don't be influenced in your pursuit of a just verdict if it happens to be different from the other jurors. Stand by your decision, and at the same time freely and fairly discuss it with the other jurors."

The jury deliberated for twenty-seven hours over two days. They requested the defense's photographs of the bathroom as well as the prosecution's diagram of the bathroom. They also called for various items specifically associated with Allene's wounds: drawings of the "flap wound," X-rays of her skull and Dr. Saier's autopsy report.

The next day, the jury told Trabucco that after thirty-six hours of deliberation, they were deadlocked 9–3 for conviction but did not spell out which form of conviction the majority favored. Trabucco asked each juror in turn, "Do you believe it possible to agree on a verdict if you are permitted to deliberate further?"

Each juror replied, "No." The foreman, Milton Raymond, said the jury had cast ten ballots. Both prosecution and defense agreed with the judge that the jury should be discharged. After Lindsay's request that Lamson remain in jail, the third trial of David Lamson was over.

11.

Cleaning Up Santa Clara County

At this point, District Attorney Fred Thomas had two options: schedule a fourth trial or dismiss the charges.

Petitions circulated in San Jose, Palo Alto and other peninsula towns demanding that the charges be dropped. The area's most influential newspaper, the *San Jose News*, published editorials to convince Thomas to drop the charges. The newspaper also reported that Lamson's defense team had evidence that two jurors had lied during the impaneling process since they had already expressed the opinion that Lamson should hang.

Furthermore, Yvor Winters was keen to point out, the jury had strange ways of doing business. One juror believed the death was an accident but "felt sure that someone else had a hand in it." Another believed David Lamson had to be guilty because the first jury had found him so. And finally, most frustrating of all, several jurors demanded proof that Lamson was innocent rather than presuming him so unless proven otherwise.

Even Judge Trabucco pressured District Attorney Thomas to move up the date when he would announce his plans for Lamson's case. The jury's foreman, Milton Raymond, said no Santa Clara County jury would ever convict Lamson. The 9–3 voting ratio on the first ballot never changed. "We took the other [nine] ballots," Raymond said, "only because we knew the judge expected us to, and that if we didn't, he'd keep us for days."

Trabucco told reporters that as far as he was concerned, it would not matter what Thomas announced, because he would disqualify himself: "Two Lamson trials in a row are too much for this judge," he said.

Thomas was getting weary, too. "I believe Lamson guilty of murder," he announced, as if the numbers were his props. "He was convicted by the first jury, and eighteen jurors found him guilty the last two trials." But justice was so uncooperative: "The supreme court reversal of the first-trial verdict is what knocked the case to pieces for us."

Lamson's final day in court came a week later, on April 3, 1936, three years after his arrest. Thomas stood before Judge Trabucco to read a statement. Notably absent were his deputy, A.P. Lindsay, who had primary responsibility for the prosecution, and Frank Thorpe, Allene's brother. Neither man had ever missed a day in a Lamson courtroom before.

Thomas said he had sincerely believed that a conviction would result from their "tireless effort…to gather evidence." But the situation had changed: "We are unable to produce any new evidence." Of course, it never occurred to him that there was no evidence to collect.

Furthermore, he continued, the widespread publicity would make a unanimous verdict impossible, since "it has been discussed over radio; in churches; on streets, in fact, everywhere opinions have been formed; it has become partisan." Friedman would have agreed but for different reasons. When the first jury was locked up, they reflected "the sentiment that existed in the county," presumably for conviction. But since then, "that sentiment has changed" in favor of Lamson's innocence. If the jury "could have circulated about among people they would have learned of this change." Of course, he knew that jurors would be forbidden to discuss such matters with family or friends.

This was a backhanded compliment to the publicity generated by the Lamson Defense Committee. Later, Rea had another angle; he made it clear that the missing Lindsay—reported "to have left San Jose for the day"—was the real culprit. "I have always had great confidence in the integrity of Fred Thomas," Rea announced, "if he ever took things directly into his own hands."

Thomas concluded with a legally crisp statement that meant Lamson was free: "I move the information herein be dismissed."

Crowds of well-wishers swarmed around Lamson. Eventually, he had to be led away through a back door because of the press of the crowd. Lamson reestablished contact with his daughter, now five, who had been living with his sister in Palo Alto. Jenny, as she would later be called, apparently did not recognize him at first and worried where he would sleep. Her first name was the same as her mother's, but the family had been calling her Bebe for the last three years.

Lamson's homecoming was, of course, not to 622 Salvatierra, sold long ago, but to Creek Drive in Palo Alto, where Dr. Lamson lived. Reporters crowded into the small house, wondering if Lamson had anticipated his release this day. "Not a glimmer," he replied. He thought Thomas "would surely go again." "Incredulity" was how he described his feelings when he realized what Thomas's statement meant.

He talked of writing more books (but only nonfiction); of visiting his ailing father, who lived in Calgary, Canada; and always of traveling with his daughter.

Frank Elles, the gum-chewing juror from Lamson's second trial, was a surprise visitor to the house that day. He not only believed in Lamson's innocence but had become his friend as well. Elles dismissed Thomas's statistical analysis of the jurors voting for Lamson's conviction with a joke: there were never thirty-six jurors altogether, Elles said, because the California Supreme Court "said the first twelve weren't jurymen at all!"

A student reporter from Stanford University asked Lamson about Stanford. He was genial and evasive: "I'm going to stay here and take it easy for awhile. As for visiting Stanford, I haven't thought about it yet. By the way, how is the old place—still going strong?" It was, but never again with his presence.

When it was time for lunch, the reporters left. One of them wrote that Lamson was finally "a free man surrounded by those who loved him."

Lamson's day of release coincided with a dramatic news flash. "Hangman" Buffington, his chief accuser, had also not attended Lamson's last day in court. Just fifteen minutes before the district attorney read the statement leading to Lamson's release, Buffington had a heart attack and died soon after.

After thirty years of service to county government, imprisoning countless evildoers, his exit raised a big question. Was he stricken because he knew Lamson was getting away? Local newspapers played with that irony for a day or so, but the fact remains that Buffington, deputy sheriff and chief jailer, in the end was inextricably bound to the Lamson case. He never wavered in his belief in Lamson's guilt.

The day Buffington died, the *Palo Alto Times* editorial page found its voice and offered the advice that Winters, Lamson's chief supporter, had been saying for the last two years. Unincorporated Santa Clara County, so filled with "gambling resorts and vice centers," badly needed a cleanup from the sheriff's department. Perhaps more leaders would add "genuine zeal on the sheriff's part" so that the county could be rid of "these illegal resorts that have notoriously enjoyed wide openings for some time."

The editorial finally brought out into the open what the local grand jury, reporting to Lamson's first judge, R.R. Syer, had said the year before. Grambling was widespread, with an especially large take from the Palo Alto and Stanford University vicinity. Not only slot machines and pinball games for money prizes but also roulette, blackjack, games of dice and numerous horse-racing "books" flourished.

Lamson's fate was linked to those games of chance in ways his defense committee understood but could not publicize. He was also caught up in the same currents of public sensationalism that brought the notorious Bruno Hauptman, Baby Lindbergh's convicted murderer, to the death chamber the very day Lamson was released. In April 1936, however, Lamson's days in Palo Alto as a public figure were over.

12.

PRISONS IN HOLLYWOOD

In the first days after his release, Lamson became the father his daughter had missed. He took her out often, going to the movies and to a circus. Out about town, he said, "people are wonderful to me. Every time I go shopping in Palo Alto, from five to ten people want to shake my hand." He added, more darkly, "perhaps my enemies don't recognize me, for I haven't been slighted, so far as I know."

He began reading about two thousand letters he received about his release, most of them congratulatory. A letter from Arkansas was quoted by the *Stanford Daily* as typical of the lot: "I was for you in your uphill fight. Now I can sleep nights."

Lamson's desires were simple enough: "I want to be just the old me, now that it's over." He was spending his afternoons with daughter Jenny and his evenings with friends: "The rest of the time I just live, and that's a great sensation."

Regaining his earlier identity was moot. He was now a single parent, with a public reputation, embarking on a Hollywood writing career, having sold *We Who Are About to Die* to RKO-Radio Pictures.

Lamson left Palo Alto within ten days of his release from jail to go to Hollywood to write the screenplay for this bestseller about San Quentin. RKO, one of Hollywood's "big five" production companies, was then celebrating its most profitable year since 1921. In 1937, when *We Who Are About to Die* was filmed, RKO was at the height of its production output, releasing a film a week. Its only really big hit that year was Walt Disney's first animated feature, *Snow White and the Seven Dwarfs*.

Lamson's decision to go to Hollywood would be, he said, his "way of justifying" himself "in the eyes of friends who helped me." Having had "an unusual experience, learning a lot about what happens to ordinary people suddenly placed in the position of a social enemy" gave him a "story" to tell. In addition to a share of the screen rights, Lamson received a salary as screenwriter.

He boosted the 1930s vogue for convict films in general and death row dramas in particular. Popular star Preston Foster had already played a killer in two of them. *I Am a Fugitive from a Chain Gang* (1932), one of the most famous convict films of the decade, was based on the autobiography of Robert Burns (Paul Muni), an innocent man sentenced to a brutal chain gang in Alabama. Burns escapes with Pete, a down-and-outer played by Foster, who holds up a deli counter-man but is killed in a gunfight with police.

In the same year, Foster played Killer Mears, a nasty murderer who leads a takeover of death row in *The Last Mile*, where Richard Walters (Howard Phillips), an innocent man, awaits hanging. All the cliches of prison dramas are developed, including a sadistic guard murdered by Mears. Unexpectedly, *The Last Mile* is introduced by a lengthy speech against capital punishment by Lewis Edward Lawes, the warden of Sing Sing Prison and the author of a bestselling autobiography, *Twenty Thousand Years in Sing Sing* (1932).

RKO derailed Lamson's story by assigning one of its specialty rewrite men, John Twist, who ended up sharing screenwriting credits with Lamson. Twist's job at RKO was to work on stories that producers purchased, according to the *New York Times*, "on impulse." In order to control the budget, Twist would rewrite the original script to reduce the number of sets and actors.

Lamson's portraits of his fellow cons survived the Hollywood adaptation process, even if the film credits read "from the novel by Lamson." The evidence that a gang plants on the hapless Lamson stand-in, John (John Beal), will remind some viewers of the iron pipe and bloodstains foisted on Lamson by the Santa Clara authorities. The filmmakers added the San Jose lynching to the plot, when John's car, stolen by the killers to frame him, accidentally runs over a child. The child's father leads a mob of workers in a lynching attempt. The prosecutor wants to be governor, so he looks the other way. The Hollywood "Twist" includes a detective (Preston Foster) who is in love with our victim's girlfriend (Ann Dvorak) and an attempted prison break. Despite riots and the murder of a guard or two, the hero is rescued with a last-minute pardon.

Although one reviewer called it a "fair" film, *Variety*, Hollywood's trade paper, enthused that it was "well put together and with suspense," a film with "strong masculine appeal." The *New York Times* reviewer argued that RKO's

A still from the film *We Who Are About to Die*, 1937, set in San Quentin State Prison, with John Beal playing Johnny—a stand-in for David Lamson—and Ann Dvorak playing his girlfriend, Connie Stewart. *Author's collection.*

take on Lamson's thirteen months on Murderers' Row didn't have enough drama. He was right. The real drama was his legal lynching.

Within eight months, Warner Bros., the studio whose social concern films began with *I Am a Fugitive on a Chain Gang*, released *San Quentin*, in which Humphrey Bogart plays an angry con whose sister (Ann Sheridan) attracts the interest of his prison captain (Pat O'Brien). The film intercuts stunning documentary shots of thousands of prisoners milling in the actual San Quentin yard. When Bogart escapes from a road gang, the prison captain

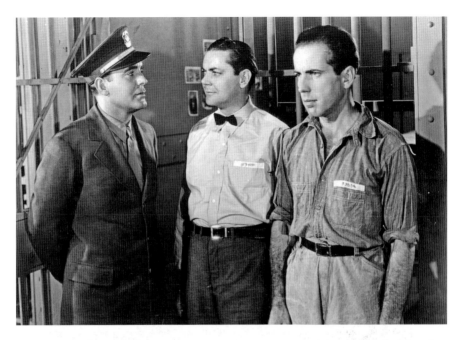

A still from the film *San Quentin* (1937). The prison captain (Pat O'Brien) is on the left and the prisoner (Humphrey Bogart) is on the right, flanking a prison guard. *Author's collection.*

is falsely blamed for making the escape possible by giving Bogart a soft job. Although Bogart was not yet at the height of his fame, his combination of tough and smart established this version of San Quentin, not Lamson's or Foster's, as a box-office hit.

Fortunately for Lamson, his novel *Whirlpool* became another bestseller in 1937. The *Saturday Review of Literature* called it more impressive "as social criticism than as fiction" and noted that there was "a persistent note of bitterness under the surface of the writing." But the *New York Times* reviewer was more enthusiastic about this paradox, saying the lack of "bitterness" in the storytelling made it "all the more cuttingly effective." Neither reviewer noticed that it was autobiographical.

Lamson had read about Bill Wilson in *Convicting the Innocent*, a Yale University professor's compilation and analysis of unjust convictions. In 1916, Wilson was convicted of murdering his wife and nineteen-month-old daughter. Wilson denied the charges; he said his wife had left him and had taken the baby. The case against him was a mixture of direct and circumstantial evidence. Even the farmer who found an "incriminating" shallow mound of very old bones thought they were part of an ancient Indian burial. The circumstantial case against Wilson included hostile

remarks against his wife that he had supposedly made, an axe handle found near the bones and a spot of blood on a rock nearby. The prosecutor, despite obvious flaws in his case, was relentless for conviction.

Although experts testified that the bones had not been recently buried, Wilson was convicted and sentenced to life imprisonment. Only the discovery of his wife and child, alive and well in another state, saved Wilson. The bones did turn out to be the remains of four or five ancient Indian skeletons.

In *Whirlpool*, Lamson reworked Wilson's story with significant elements from his own case. The novel begins with a fight between Hannibal and Joel Norfolk, two brothers, over Hannibal's flirtatious wife. After Joel, the younger brother, goes missing, an obnoxious neighbor, visiting the spot of the struggle, finds the younger brother's watch and some blood-soaked cloths. As in the Wilson case, a pile of bones is also unearthed, and a chain of circumstantial evidence against Hannibal is wound tighter and tighter.

Although Lamson's acknowledgement makes the customary disclaimer that "no analogy with actual people, places, or events is intended," his novel delivers a portrait of "Hangman" Buffington, who, in the novel, as Undersheriff Albert Prouty, tries to convince Hannibal that he is "a little sick" in the head. Prouty, like "Hangman," knows how, where and why Hannibal killed his brother.

Lamson transformed his first San Jose jury into Hannibal's, using virtually the same details of Nellie Clemence's reversal of her potential verdict of innocence. In the novel, the hold-out juror is told the sordid details of a case that lawyers weren't "allowed" to bring out in court. Instead of Lamson's supposed addiction, for example, his fictional counterpart has congenital syphilis. After hearing this and other horrors, the jury achieves unanimity.

Perhaps as a projection of nightmares, Lamson does not allow Hannibal's conviction to be reversed in time. His younger brother is found alive and well, but by the time the news makes it back to the prison, Hannibal, desperate to visit his pregnant wife, has been gunned down trying to escape.

With two bestsellers and a film adaptation, Lamson turned to the *Saturday Evening Post* market for short stories. The *Post* was a well-paying, prestigious outlet for writers in the 1930s. The Pulitzer Prize in fiction for 1937, for example, went to J.P. Marquand's *The Late George Apley*, first serialized in the *Post*. Lamson's first story, "Oh, Once in My Saddle," about life in Canada, appeared in April 1937. He published almost eighty stories for the *Post* over a fifteen-year period.

Lamson's story caused problems among some of the California readers of the *Post*. Having spotted Lamson's name, about "a score of letters of protest, almost all from San Jose," complained of Lamson's appearance.

The editor of the *Post*, Wesley Winnans Stout, replied to the letters with a brief recitation of the facts of the case and the statement that the *Post* "shall continue to treat Mr. Lamson as we should anyone else." By this he meant that the stories would be accepted on their merits only. In any case, Stout wrote, "The *Post* never believed him guilty."

Lamson's second story appeared soon after. "Schoolteachers Don't Know Everything" was also a fictionalized account of Lamson's youth in Alberta. "Keeping Posted," the column of news about contributors, included a long discussion of Lamson's background as a boy in rural Canada and even included a picture of Lamson, nine years old, chopping wood with his father. It again briefly reviewed his case and listed his hobbies as "rearing a daughter, aged seven, gardening and scratching a fiddle." His "pet hates" were parties, golf and bridge. As for the latter…Allene had been his bridge partner.

"What he really enjoys," the *Post* concluded, is "wrestling with the technique of the short story." The transformation of David Lamson from celebrity writer to professional writer was complete.

Lamson's publications in the *Post* gave him a comfortable but certainly not lucrative income. He moved to the former gold rush territory known as Grass Valley, near Nevada City, in northeastern California, in 1940. It resembled the Canadian wilderness of his youth. He married Ruth Rankin, who also became a *Post* contributor.

He returned to the Stanford area only in 1954, eventually becoming an early computer analyst for the maintenance department of United Airlines. His early radicalism and even sympathy for the communist organizers in the valley began to change, Janet Lewis believed, as Lamson worked for a business supportive of its management team.

Winters and Lewis, the key members of his defense committee, continued as his close friends, and their children played with Lamson's daughter, Jenny, as he had moved near them in Los Altos. Lamson's sister Margaret remained Janet Lewis's doctor.

Winters and Lewis believed, however, that *his* position at Stanford—low pay and less recognition for his achievements—reflected anti-Lamson prejudice at Stanford. Jenny Lamson said that she was told point-blank by Stanford officials that she would be happier as a student elsewhere, even though her mother's sorority sisters and friends had guaranteed a Stanford scholarship for her in the early 1930s.

Winters eventually published three poems about his experience with the Lamson case, poems that critic and poet Dana Gioia described as the "accessible, realistic and auditory" essence of the West Coast's populist

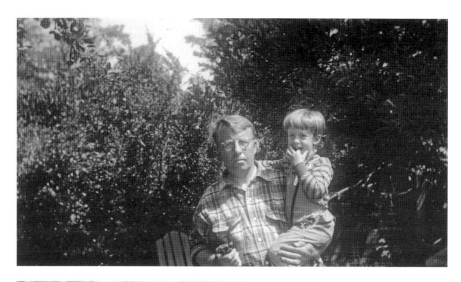

Above: Yvor Winters with son Daniel at home in Los Altos in the 1930s. *Courtesy Melissa K. Winters.*

Left: Yvor Winters and Janet Lewis, poet and novelist, with daughter Joanna at home in Los Altos in the 1930s. *Courtesy Melissa K. Winters.*

literary tradition. The poems memorialized Lamson, his sister and McKenzie and excoriated the corruption of Santa Clara and its prosecutors, as well as the gullibility of the public and the venal lack of rational judgment of the university community. In "To a Woman on Her Defense of Her Brother Unjustly Convicted of Murder," Winters wrote that Lamson's sister "for an evil year" had "fought" the "brutal power, judicial and sedate." Appalled by how the prosecutors twisted Lamson's poetry amid the tacit approval of some of his university colleagues, including English professors, he wrote in "For David Lamson":

> *May I state my grief and shame*
> *At the scholar's empty name:*
> *How great scholars failed to see*
> *Virtue in extremity.*

In Winters's "To Edwin McKenzie," the lawyer was nothing short of heroic:

> *When those who guard tradition in the schools*
> *Proved to be weaklings and half-learned fools,*
> *You took the burden, saved the intellect,*
> *Combating treason, mastering each defect,*
> *You fought your battle, inch by inch of ground.*

Winters's enduring friendship with Lamson was tested years later. Richard Elman, a former student of Winters and a minor novelist, proposed a novel about the Lamson case. "For God's sake," Winters wrote to Elman, "keep your hands off the Lamsons; they have been through enough." Lamson had had a heart attack in the early 1960s, and just hearing about Elman's book upset him so much he "might easily have another." Drawing a vivid picture of Elman's proposed book generating a TV crew hounding Lamson and his family, Winters explained what he would do if reporters came to *his* door asking about the case: "If they do I will meet them with a gun and a bulldog."

Elman later lied about giving up the Lamson book; Winters believed him and was relieved, but he chastised Elman for being naïve about Santa Clara County and its corruption, hidden from public scrutiny even then, in the late 1960s. Winters reminded Elman of Oneal's extortion attempt and suggested he even controlled one of Lamson's lawyers (Rankin). The public atmosphere was still toxic: a few years earlier, Winters had overheard

a Stanford colleague with "his low-pitched academic giggle" discussing Winters's poems as well as Lamson: "Of course everybody knows he was guilty as hell."

Nonetheless, Elman did publish his novel about the case, *An Education in Blood*, four years later and followed it with a number of duplicitous and self-serving essays about his relationships with Winters and Lamson. Thirty years later, Elman was still pretending that his novel "was clearly a work of fiction, set in a different part of the state, and inhabited by characters who had no real resemblance to David Lamson." Elman's research was hopeless: he said Lamson had had only one trial (instead of three) and that three "organizers" were lynched in San Jose, not the two hapless unemployed kidnappers. Despite assuring Lamson that he would not write about the case, Elman proceeded to do exactly that, portraying in his novel every major detail from the ordeal, although in the end instead of an accidental fall Elman's stand-in angrily pushes his wife in the bathtub, causing her death. Manslaughter in more ways than one!

Lamson died on August 6, 1975, at El Camino Hospital in Mountain View, Palo Alto's neighboring community to the south, three miles from 622 Salvatierra. He had been ill with a weak heart for quite awhile.

District Attorney Fred Thomas told the *Palo Alto Times* long after the trials were over that Lamson "doesn't stand absolved." "No jury ever acquitted him," he added. "Thirty out of the thirty-six jurors who tried him said he was guilty. That is the judgment of the people."

Thomas's arithmetic had been flawless for many years. A week before the case against Lamson was finally dismissed, in late March 1937, Thomas had boasted that all the members of the first jury and eighteen out of the twenty-four jurors in the second and third trials "found him guilty." "I believe Lamson guilty of murder," he said then.

Thomas of course knew that conviction in the jury system of the United States is not based on majority rule but unanimity. He had only his numbers to console him because he had to dismiss the charges against Lamson.

13.

SILICON VALLEY:
NOT A FRUIT TREE REMAINS

Visitors to Silicon Valley see virtually a seamless web of high-tech industries stretching from Stanford's southern edge, through Sunnyvale, to San Jose at the southern end of the county. This suburban sprawl created by computers and microchips has grown from the Hewlett-Packard Company, once the largest employer in the area's personal computer industry, founded in 1939 by two of Stanford's most successful graduates, William Hewlett and David Packard, just two years after Lamson's charges were dismissed

But Stanford University is not solely to blame for the end of Santa Clara as the Valley of Heart's Delight. The federal government and its growing defense budgets were also responsible. The beginning of the end for Santa Clara Valley orchardists was marked by two at first unrelated events: the construction of a $5 million dirigible hangar in Sunnyvale and the arrival of Frederick Terman at Stanford's engineering department.

Hangar One was built in 1933 to house the USS *Macon*, one of two sister ships designed to lead the navy's dirigible fleet. The Naval Air Station and Hangar One—a unique structure over eleven hundred feet long, three hundred feet wide and almost two hundred feet high—replaced a huge orchard. It would keep the *Macon* snug when at home base.

Winters often joked that the hangar had its own "weather." Built the year Allene died, it is a symbol and reality of the aerospace/defense industry of the valley. Dirigibles were spectacular but remarkably unstable, perhaps because they carried aircraft in their bellies. The *Macon*'s sister

View of Hangar One of the Naval Air Station, Moffett Field, Santa Clara County, mid-1930s, from the Historic American Buildings Survey. *Courtesy Special Collections, Stanford University.*

ship, the USS *Akron*, crashed off the New Jersey coast in a severe storm in 1933, killing seventy-three men, including the namesake of Moffett Field, Admiral W.A. Moffett. The following year, the recently repaired *Macon* crashed at Big Sur. Janet Lewis's novel *Against the Darkening Sky* dramatizes a family whose lives are punctuated by the crash of the *Macon* and a kidnapping, both part of the metaphorical "darkening sky" over the valley. She also wrote of the loss of the *Macon* in her poem "The Hangar at Sunnyvale, 1937":

> *Above the marsh, a hollow monument,*
> *Ribbed with aluminum, enormous tent*
> *Sheeted with silver, set to face the gale*
> *Of the steady wind that filled the clipper sail,*
> *The hangar stands. With doors now buckled close*
> *Against the summer wind, the empty house*
> *Reserves a space shaped to the foundered dream.*
> *The Macon, lost, moves with the ocean stream.*

Above: USS *Macon* leaving the south circle near Hangar One, March 21, 1933. *Courtesy U.S. Navy Photo.*

Right: Janet Lewis at home in Los Altos, 1930s. *Courtesy Special Collections, Stanford University.*

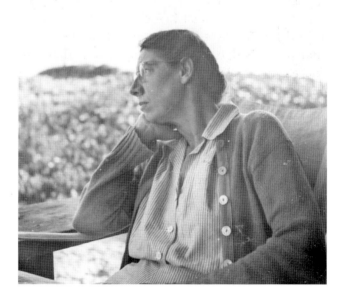

Two of Terman's outstanding engineering students, Hewlett and Packard, graduated in 1934. Although briefly separated, the two were reunited in a Palo Alto garage five years later, when they made their first audio oscillator, used for testing sound equipment and the subject of Hewlett's Stanford master's degree thesis. The new company sold eight of the machines to Disney for testing the stereophonic soundtrack of the animated *Fantasia*, released in 1940.

In 1954, Terman, now dean of the engineering school, pushed for the creation of the Stanford Industrial Park, home to radar and electronic companies, including Hewlett-Packard. Terman's own mentor in the doctoral program at MIT had been Vannevar Bush, a leading governmental scientific advisor and eventually one of the four founders of Raytheon Corporation.

That same year, Ames Aerospace Laboratories extended its facilities to former orchards adjoining Moffett Field. Lockheed within three years had expanded both in the Stanford Industrial Park and near Moffett Field. At the extreme southern end of the county, just south of San Jose, IBM in 1953 had erected one of its largest manufacturing plants. Silicon Valley, from Stanford to San Jose, was in place.

The 1960s accelerated the presence of federal contracting for Santa Clara industries. California overall was already first in federal defense money. By 1965, it was estimated that 50 percent of all the jobs in California were related, directly or indirectly, to defense and space contracts.

When Steve Wozniak and Steve Jobs founded Apple Computers in the 1970s, Silicon Valley was now internationally prominent. Both were graduates of Berkeley, however, which may explain why Hewlett-Packard at first did not support their idea for a personal computer. Recapitulating the modest origins of the Hewlett-Packard Company, Wozniak and Jobs built their first personal computer in a Los Altos garage in 1976. They called it an Apple, but not the kind from the Valley of Heart's Delight.

Wallace Stegner, novelist, chronicler of the West and a professor at Stanford, believed that Silicon Valley "is probably a good, in many ways," but "the Valley of Heart's Delight was a glory. We should have found ways of keeping the one from destroying the other." For him the woodsman's axe in Chekhov's *The Cherry Orchard* destroyed the Valley of Heart's Delight, and Eden was lost: "A distant sound is heard, coming as if out of the sky, like the sound of a string snapping, slowly and sadly dying away. Silence ensues, broken only by the sound of an ax striking a tree in the orchard far away."

While an axe fells trees one at a time, bulldozers do whole orchards in a day. By 1984, the county's last twenty-one thousand acres of fruit had been

picked by Mexican migrant labor, whose poor living conditions have always been regrettable. By 1996, only three orchards remained in the entire valley, and they were "living museums," not commercial enterprises. One of them, the David Packard Orchard in Los Altos Hills, remains a special oddity, as it is cultivated by the father of Silicon Valley and was open for years for his employees to pick apricots.

By the end of the century, the Santa Clara Valley orchards whose pickers were both native-born and immigrant had given way to the thousands of Southeast Asians, most of whom began work in Silicon Valley assembling circuit boards. The Valley of Heart's Delight was gone forever.

Sources

I interviewed Janet Lewis and Jenny Jacobs, formerly Allene Genevieve Lamson, David Lamson's daughter, in Los Altos, California, on September 30, 1988. I consulted transcripts of other interviews with Janet Lewis by Margo Davis, November 14–18, 1977, and Brigitte Carnochan, September 8 and 15, 1980, in the Stanford University Archives. I read the unpublished correspondence of Janet Lewis and Katherine Anne Porter in the Special Collections of the University of Maryland.

I have benefited from unpublished materials written by Yvor Winters during the 1930s, specifically both his notes on index cards and his "Lamson Case: An Appendix," intended for Lamson's memoir, *We Who Are About to Die*.

I have corresponded with three Stanford student reporters present at the trials: Albert J. Guerard (United Press), Charles R. Chappell and Julius Jacobs (both *Stanford Daily*).

I exchanged e-mails in 2002 with Lynn Jean of Saskatchewan, whose great-uncle Dick Sharpe was shot and killed accidentally (the coroner ruled) by Lamson in 1915.

I have consulted the papers of Yvor Winters, Janet Lewis, Lowell Turrentine, Ray Lyman Wilbur and D.L. Webster, as well as the David Lamson case folder, all in the Department of Special Collections, Stanford University Library.

For information about the San Jose lynchings and Louis Oneal's role as the political boss of Santa Clara County, I am indebted to Harry Farrell's excellent narrative *Swift Justice: Murder and Vengeance in a California Town*.

I consulted the back issues of the *Palo Alto Times*, the *Stanford Daily* and the *San Jose Mercury News* (1928–36) and the *New York Times* (1933–36), as well as the motions and depositions of the trials in 1933, 1935 and 1936 at the Santa Clara County Courthouse in San Jose.

In addition to the following list of sources, I read articles about the Lamson trials in *Time* and *Newsweek* (1933–36) and a number of Lamson's short stories that appeared in the *Saturday Evening Post* (1937–57), many of which were not reprinted in his short story collection *Once in My Saddle*.

Adamic, Louis. *Dynamite: The Story of Class Violence in America* (1931). Second rev. ed., 1934. Rpt. New York: Chelsea House, 1968.

Alix, Ernest Kahler. *Ransom Kidnapping in America, 1874–1974: The Creation of a Capital Crime.* Carbondale: Southern Illinois Press, 1978.

Allen, Peter C. *Stanford from the Beginning.* Ninth rev. ed. Stanford, CA: Office of Public Affairs, 1986.

Always in Style: Fifty Years of Stanford Architecture 1891–1941. Stanford Observer, October 1987, 9–16.

Baker, Howard. "Death Row." *The New Republic,* November 27, 1935, 81.

Bean, Walter, and James Rawls. *California: An Interpretive History.* Tenth ed. New York: McGraw-Hill, 2011.

Bedau, Hugo Adam, and Michael L. Radelet. "Miscarriages of Justice in Potentially Capital Cases." *Stanford Law Review* 40 (November 1987): 21–179.

Block, Eugene B. *And May God Have Mercy.* San Francisco: Fearon Publishers, 1962. Revised as *When Men Play God: The Fallacies of Capital Punishment.* San Francisco: Cragmont, 1983.

———. *The Fabric of Guilt.* Garden City, NY: Doubleday, 1968.

———. *The Vindicators.* Garden City, NY: Doubleday, 1963.

———. *The Wizard of Berkeley.* New York: Coward-McCann, 1958.

"Blood Spurt." *Time,* April 8, 1935, 32–33.

Bobonich, Chris and Harry Bobonich. *Bloody Ivy: Sixteen Unsolved Murders.* Bloomington, IN: AuthorHouse, 2013.

Bolting, Douglas. *The Great Airships.* Alexandria, VA: Time-Life, 1980.

Borchard, Edwin Montefiore. *Convicting the Innocent.* New Haven, CT: Yale University Press, 1932.

Brazil, Jeff. "Recalling the Peninsula's Best-Known Capital Case." *Peninsula Times Tribune,* May 26, 1996, A1, A8.

Brier, Royce. "Lynching in San Jose." In *The San Francisco Chronicle Reader,* edited by William Hogan and William German. New York: McGraw-Hill, 1962.

Broek, Jan Otto Marius. *The Santa Clara Valley: A Study in Landscape Changes.* Utrecht: N.V.A. OOsthoek's Uitgevers Mij, 1932.

Butcher, Bernard. "Was It Murder?" *Stanford Magazine,* January–February 2000: 76–83.

California: A Guide to the Golden State (1939). Rpt. New York: Hastings House, 1972.

Carnochan, Brigitte. "An Interview with Janet Lewis." *Canto* 4 (June 1981): 52–71.

———. *The Strength of Art: Poets and Poetry in the Lives of Yvor Winters and Janet Lewis.* Stanford, CA: Stanford University Libraries, 1984.

———. *Two Poets: A Life Together.* Menlo Park, CA: Occasional Works, 2001.

Change, Gordon. *Morning Glory, Evening Shadow: Yamato Ichihashi and His Internment Writings, 1942–1945.* Stanford, CA: Stanford University Press, 1999.

Chapman, Robin. *California Apricots.* Charleston, SC: The History Press, 2013.

Churchill, Douglas W. "The Clouded Hollywood Horizon." *New York Times,* October 18, 1936.

———. "Hello, Central—Hollywood Calling." *New York Times,* January 29, 1939.

Clark, Basil. *The History of Airships.* New York: St. Martin's, 1961.

Coffman, Arthur. *An Illustrated History of Palo Alto.* Palo Alto, CA: Lewis Osborne, 1969.

Crow, Charles L. *Janet Lewis.* Boise, ID: Boise State University Western Writers Series (No. 41), 1980.

"Death for Nothing." *Time,* February 17, 1936, 13.

De Roos, Robert. "Stanford Greats: Edith Mirrielees." *Stanford Observer,* October 1988, 21.

Dillon, Millicent. "Albert Guerard Savors the Memories of His Productive Literary Life." *Stanford Observer,* April 1982, 13–14.

Duffy, Clinton J. *The San Quentin Story.* Garden City, NY: Doubleday, 1950.

Elliott, Orrin Leslie. *Stanford University: The First Twenty-Five Years.* Stanford, CA: Stanford University Press, 1937.

Elman, Richard M. *An Education in Blood.* New York: Charles Scribner's Sons, 1971.

———. *Namedropping: Mostly Literary Memoirs.* Albany: State University of New York Press, 1998.

Farrell, Harry. *Swift Justice: Murder and Vengeance in a California Town.* New York: St. Martin's, 1992.

Fields, Ken. "True to His Word." *Stanford Magazine,* November–December 2000.

———. "Winters' Wild West." *Los Angeles Review of Books,* September 10, 2013.

Fraser, John. "Yvor Winters: The Perils of Mind." In *The Name of Action: Critical Essays*. Cambridge, UK: Cambridge University Press, 1984, 132–51.

Frost, Richard H. *The Mooney Case*. Stanford, CA: Stanford University Press, 1968.

Gardner, Erle Stanley. *The Court of Last Resort*. New York: William Sloan, 1957.

Gentry, Curt. *Frame-Up: The Incredible Case of Tom Mooney and Warren Billings*. New York: Norton, 1967.

Gioia, Dana. "Fallen Western Star: The Decline of San Francisco as a Literary Region." In *The "Fallen Western Star" Wars: A Debate about Literary California*, edited by Jack Foley. Oakland, CA: Scarlet Tanager Press, 2001.

Grant, Joanne. "1933 Murder Hearing Captured on Film." *San Jose Mercury News*, January 13, 1992, B1–2.

Gregg, Robert C., et al. *Glory of Angels: Stanford Memorial Church*. Stanford, CA: Stanford Alumni Association, 1995.

Hall, Mordaunt. "Life Ends: *The Last Mile*." *New York Times*, August 24, 1932.

Hayes, Dennis. *Beyond the Silicon Curtain: The Seduction of Work in a Lonely Era*. Boston: South End Press, 1989.

Healey, Dorothy, and Maurice Isserman. *Dorothy Healey Remembers: A Life in the American Communist Party*. New York: Oxford University Press, 1990.

Herzog, Todd. *Crime Stories*. New York: Berghahn Books, 2009.

Hewlett-Packard Company. Hewlett-Packet Virtual Museum. http://www.hp.com/hpinfo/abouthp/histnfacts/museum.

Hogan, William, and William German, eds. *The San Francisco Chronicle Reader*. New York: McGraw-Hill, 1962.

Hoyt, Edwin P. *Alexander Woollcott: The Man Who Came to Dinner*. London: Abelard-Schuman, 1968.

Hynding, Alan. *From Frontier to Suburb: The Story of the San Mateo Peninsula*. Belmont, CA: Star Publishing, 1982.

Jacobson, Yvonne. *Passing Farms, Enduring Values: California's Santa Clara Valley*. Los Altos, CA: William Kaufmann, 1984.

Jane Stanford's Inscriptions on the Interior Walls of Memorial Church. Stanford, CA: Stanford Memorial Church, n.d.

Jewell, Richard B., and Vernon Harbin. *The RKO Story*. New York: Arlington House, 1982.

Johnson, Edith E. *Leaves from a Doctor's Diary*. Palo Alto, CA: Pacific Books, 1954.

Johnston, Moira. "Silicon Valley—Cradle of the Chip." *National Geographic* 162 (October 1982): 459–77.

Lambert, Richard S. *When Justice Faltered: A Study of Nine Peculiar Murder Trials*. London: Methuen, 1935.

Lamson, David. *Once in My Saddle.* New York: Charles Scribner's Sons, 1940.

———. *We Who Are About to Die: Prison as Seen by a Condemned Man.* New York: Charles Scribner's Sons, 1935.

———. *Whirlpool.* New York: Charles Scribner's Sons, 1937.

Levin, David. "In the Court of Historical Criticism: Alger Hiss's Narrative." *Virginia Quarterly Review* (Winter 1976): 41–78.

———. "Yvor Winters at Stanford." *Virginia Quarterly Review* 54 (Summer 1978): 454–73.

Levine, Philip. "The Shadow of the Big Madrone." In *The Bread of Time: Toward an Autobiography.* New York: Alfred A. Knopf, 1995, 204–59.

Lewis, Janet. *Against a Darkening Sky.* New York: Doubleday, Doran, 1943.

———. *Good-Bye Son and Other Stories.* New York: Doubleday, 1946. Rpt. Athens, OH: Swallow Press, 1986.

———. *Poems Old and New: 1918–1978.* Chicago: Swallow Press, 1981.

———. *The Selected Poems of Janet Lewis.* Edited by Robert L. Barth. Athens: Swallow Press/Ohio University Press, 2000.

———. "Sources of *The Wife of Martin Guerre.*" *Triquarterly* 55 (1982): 104–10.

Lewis, Oscar. *The Big Four: The Story of Huntington, Stanford, Hopkins, and Crocker, and the Building of the Central Pacific.* New York: Knopf, 1938.

MacKaye, Benton. *The New Exploration: A Philosophy of Regional Planning* (1928). Rpt. Urbana: University of Illinois Press, 1962.

MacKaye, Milton. *Dramatic Crimes of 1927.* Garden City, NY: Crime Club, 1927.

Mainwaring, Daniel. "Fruit Tramp: A Story." *Harper's Magazine,* July 1934: 235–42.

Matthews, Glenna. *Silicon Valley, Women, and the California Dream.* Stanford, CA: Stanford University Press, 2003.

McArdle, Phil, and Karen McArdle. *Fatal Fascination: Where Fact Meets Fiction in Police Work.* Boston: Houghton Mifflin, 1988.

McManus, John T. "At the Strand: *San Quentin.*" *New York Times,* August 4, 1937, 15.

McWilliams, Carey. *Factories in the Fields: The Story of Migratory Labor in California* (1939). Rpt. Santa Barbara, CA: Peregrine Smith, 1971.

———. *Prejudice: Japanese-Americans: Symbol of Racial Intolerance.* Boston: Little, Brown, 1944.

Meister, Dick, and Anne Loftis. *A Long Time Coming: The Struggle to Unionize American Farm Workers.* New York: MacMillan, 1977.

Messick, Hank, and Burt Goldblatt. *Kidnapping: The Illustrated History.* New York: Dial Press, 1974.

Miller, Guy C., ed. *Palo Alto Community Book.* Palo Alto, CA: Arthur H. Lawston, 1952.

Mirrielees, Edith R. *Stanford: The Story of a University.* New York: G.P. Putnam's Sons, 1959.

Mitchell, J. Pearce. *Stanford University: 1916–1941.* Stanford, CA: Stanford University Press, 1958.

"Mrs. Hoover's Cottages" and "Historic Houses of Lower San Juan District." Stanford Historical Society. http://histsoc.stanford.edu.

Nash, Jay Robert. *I Am Innocent! A Comprehensive Encyclopedic History of the World's Wrongly Convicted Persons.* New York: Da Capo Press, 2008.

Naval Air Station Moffett Field. Sunnyvale, CA: Public Affairs Office, 1988.

New York Times. "Kathleen Norris Is Dead at 85: Wrote More Than 80 Novels." January 19, 1966, 41.

Norris, Kathleen. "Betty Gow's Poise Praised by Writer." *New York Times,* January 8, 1935, 18.

———. *Come Back to Me, Beloved.* New York: Doubleday, 1942.

———."Eliminate Quarrels and Strive for Heaven in the Home Is Advice of Kathleen Norris." *Louisville Courier-Journal,* February 1, 1925, II, 4.

———. "Marvels at Faith of Mrs. Hauptmann." *New York Times,* January 30, 1935, 12.

———. "Mrs. Norris Finds Prisoner [Bruno Hauptmann] 'Pitiful.'" *New York Times,* January 26, 1935, 9.

———. "Novelist Sketches the Trial Scene." *New York Times,* January 3, 1935, 4.

———. "Worthless Women Do Not Triumph, as Girl with Eyes Open Knows, Mrs. Norris Says." *Louisville Courier-Journal,* February 15, 1925, II, 4.

Nugent, Frank. Review of *We Who Are About to Die. New York Times,* January 2, 1937, 15.

Palo Alto Times. "Ex–County Sheriff William Emig Dies." October 23, 1963, 1.

Payne, Stephen M. *Santa Clara County: Harvest of Change.* Northridge, CA: Windsor Publications, 1987.

Pearson, Edmund. *Studies in Murder.* New York: Modern Library, 1938.

Pejovich, Ted. *The State of California: Growing Up Foreign in the Backyards of Eden.* New York: Knopf, 1989.

People v. Lamson. 1 Cal (2d). California Supreme Court (October 13, 1934).

People v. Le Doux. 102 Pac. California Supreme Court (May 19, 1909; June 24, 1909).

People v. Staples. 86 Pac. California Supreme Court (July 10, 1906).

People v. Tedesco. 34 Pac. (2d). California Supreme Court (July 2, 1934).

Phillipps, Samuel. *Famous Cases of Circumstantial Evidence*. Fourth ed. Jersey City, NJ: Frederick Linn, 1879.

Porter, Katherine Anne. *Flowering Judas*. New York: Harcourt, Brace, 1930.

Radelet, Michael L., Hugo Bedau and Constance E. Putnam. *In Spite of Innocence: Erroneous Convictions in Capital Cases*. Boston: Northeastern University Press, 1992.

Raineri, Vivian McGuckin. *The Red Angel: The Life and Times of Elaine Black Yoneda, 1906–1988*. New York: International Publishers, 1991.

Richards, I.A. *Practical Criticism: A Study of Literary Judgment* (1929). Rpt. New York: Harcourt, Brace, and World, 1966.

Rogers, Everett M., and Judith K. Larsen. *Silicon Valley Fever: Growth of High-Technology Culture*. New York: Basic Books, 1984.

San Francisco Chronicle. "Jacobs, Jenny Lamson" [Obituary]. November 24, 2000, D99.

Siegel, Lenny, and John Markoff. *The High Cost of High Tech: The Dark Side of the Chip*. New York: Harper & Row, 1985.

Simpich, Frederick. "Northern California at Work." *National Geographic*, March 1936: 310–89.

Stanford Daily. "Mysterious Death." January 30, 1935, 1.

Stanford, Donald, and Lewis P. Simpson, eds. *Yvor Winters Issue. The Southern Review*. Autumn 1981.

Stanford Memorial Church. Stanford, CA: Stanford University Publications Service, 1964.

Stanford Observed. Stanford University News Service. *Stanford Observer*, June 1991.

Stanford 100. Stanford University News Service. *Stanford Observer*, April 1987.

Stockholm, Gail. *Stanford Memorial Church*. Edited by Donald T. Carlson. Stanford, CA: Office of Public Affairs, 1980.

Stout, Wesley Winans. "Editorial." *Saturday Evening Post*, June 4, 1938, 22.

———. "Keeping Posted." *Saturday Evening Post*, June 11, 1938, 104.

Terry, John. "Terror in San Jose." *Nation*, August 8, 1934, 161–62.

Thorwald, Jurgen. *Crime and Science: The New Frontier in Criminology*. New York: Harcourt, Brace, 1967.

Time. "Three Trials and Out." April 13, 1946, 18–19.

Trimpi, Helen Pinkerton. "'Art Should Be Austere': The Yvor Winters Papers in the Stanford University Library." *Imprint* (Spring & Summer 2000): 21–40.

Villareal, Jose Antonio. *Pocho*. Garden City, NY: Doubleday, 1950.

Vollmer, August. *The Criminal*. Brooklyn, NY: Foundation Press, 1949.

Winters, Yvor. *Collected Poems*. Denver: Alan Swallow, 1952.

———. "More Santa Clara Justice." *The New Republic*, October 10, 1934, 239–41.

———. *The Selected Letters of Yvor Winters*. Edited by R.L. Barth. Athens: Swallow Press/Ohio University Press, 2000.

———. *The Selected Poems of Yvor Winters*. Edited by R.L. Barth. Athens: Swallow Press/Ohio University Press, 1999.

Winters, Yvor, and Frances Theresa Russell. *The Case of David Lamson*. San Fransicso: Lamson Defense Committee, 1934.

Wood, Dallas E. *History of Palo Alto*. Palo Alto, CA: Arthur H. Lawston, 1939.

Woollcott, Alexander. *The Letters of Alexander Woollcott*. Edited by Beatrice Kaufman and Joseph Hennessey. New York: Viking Press, 1944.

———. *While Rome Burns* (1934). Harmondsworth, UK: Penguin Books, 1937.

Zaniello, Tom. "The David Lamson Case: Death by Literature." *Kentucky Philological Review* 2 (1987): 6–12.

———. "Yvor Winters." *Dictionary of Literary Biography*, Vol. 48: *American Poets, 1880–1945 Second Series*. Edited by Peter Quartermain. Detroit: Gale Research Company, 1986: 445–52.

INDEX

ABOUT THE AUTHOR

Tom Zaniello taught film and cultural studies and directed the Honors Program at Northern Kentucky University. His interest in the Lamson murder mystery developed during his graduate studies at Stanford University, and he has since returned to Santa Clara County to research this book. He has been active as a film programmer for the Hill Center in Washington, D.C., as well as for the London and Liverpool Labor Film Festivals. He currently has two books in print from Cornell University Press on labor films. His works in progress include a "psycho-cinematic biography" of Alfred Hitchcock and a study of scandalous religious trials in Victorian England.

Visit us at
www.historypress.net
..
This title is also available as an e-book